iDENTIFY

RotoVision

iDENTIFY

**BUILDING BRAND THROUGH
LETTERHEADS, LOGOS
AND BUSINESS CARDS**

CHARLOTTE RIVERS

A RotoVision Book
Published and distributed by
RotoVision SA
Route Suisse 9
CH-1295 Mies
Switzerland

RotoVision SA,
Sales, Production and
Editorial Office
Sheridan House
112/116A Western Road
Hove, East Sussex
BN3 1DD
UK

Tel: +44 (0)1273 72 72 68
Fax: +44 (0)1273 72 72 69
Isdn: +44 (0)1273 73 40 46
E-mail: sales@rotovision.com
www.rotovision.com

Production and Separations in
Singapore by:
Provision Pte. Ltd.
Tel: +65 6334 7720
Fax:+65 6334 7721

Copyright © RotoVision SA
2003

10 9 8 7 6 5 4 3 2 1

ISBN 2-88046-723-3

£32.50 / $45.00

Book design by
James Emmerson

Contents >>

Adresse Postale
BP 674
78006 Versailles Cedex www.versailles.archi.fr

Introduction>>

The logos of corporations such as Nike, Shell and The Gap have become not only a major part of our culture but also our social language. These names, marks and logos of course form the core of a far wider corporate identity branding process that sees these identities applied to all areas of communications and products, including packaging, brochures and advertising.

History has it that the idea of a corporate identity began towards the end of the nineteenth century, when US companies such as Campbell Soup, Quaker Oats and H.J. Heinz employed packaging and brand names to sell their products. In 1907, architect Peter Behrens was commissioned to overhaul the visual identity and communications of the German electrical firm AEG, which is widely regarded as being the first major corporate identity commission.

The twentieth century saw many other companies in different industries adopting similar professionally designed identity programmes. Paul Rand and architect Eliot Noyes collaborated on the IBM identity in the 1950s, William Golden designed the CBS eye and by 1970, when AT&T began to apply Saul Bass's telephone symbol to its communications, extensive accompanying identity manuals had become part of the whole identity design programme.

However, it is not only the major multi-nationals that require corporate identities. At the most basic level – a logo, stationery and possibly a website – an identity is needed by almost all organisations, from small businesses to charities and educational institutions.

Essentially, before you is a showcase of some of the latest examples from around the world. The contemporary visual identities in this book focus on the smaller, emerging companies and their new identities (over the past five years)

produced by a variety of design houses in the UK, USA, Asia, Europe and Australia.

These lower profile identities often allow for more experimentation and see greater creativity in the application of an identity onto a business card or letterhead. They have been designed to appeal to the intended audience on a more personal level and to accommodate a wide variety of applications.

Grouped thematically, the first part of the book offers practical advice for both designers and potential clients on commissioning, briefing, researching, designing and producing the material parts of a basic identity system.

Anatomy of Identity explores various aspects of corporate identities, looking at what a corporate identity is, who needs one and why. With reference to major developments in the history of identity design, it distinguishes the difference between an identity and a brand, as well as taking a look at successful and not so successful designs.

A Guide to Process offers practical advice on planning and designing a client's logo and applying it to the required print matter. Although there are no set rules for identity design as such, there are certain elements and processes that are useful in all projects and these are outlined in this chapter. It provides useful guidelines on approaching a brief, developing ideas and maintaining client relationships.

A collection of thirty contemporary identity designs from around the world illustrate the variety of approaches to this process. A case study detailing the client's brief and designers' solution accompanies each project featured. Imagery looks at identity systems that make use of imagery or illustration. Logotypes and Symbols explores the design of text-based logos, while Typography focuses more on

Left>>Business Card for the Architecture School of Versailles designed by Pierre Emmanuel Meunier. **Above Right>>**Business card for and by Nitesh Mody at Moot Design **Bottom Right>>**Business card and letter head for Enmeiji, an 800-year-old Buddhist temple in Tokyo, designed by Azone and Associates, Japan.

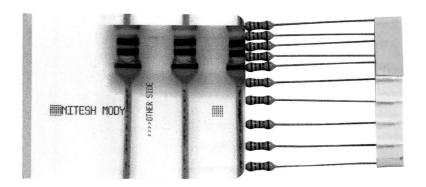

bespoke typefaces. Colour and Texture looks at designs that use corporate colours in the logo and those that use embossing or special papers to create texture. Grids and Guides looks at the provision by designers of identity guidelines that instruct the client on the layout process and the application of the identity in a range of areas, including the basic stationery set.

The last section of the book explores the creative potential of the application of an identity. This features a further thirty identity designs. Here, I explore subjects such as choice of paper and the variety of stocks available, as well as taking a look at the myriad of printing techniques available to designers today, including de-bossing, foil blocking, the use of letterpress and rubber stamps.

Each and every company, whether it be a local council, a restaurant, a photographers studio or a university, has a message to convey to its clients. It is down to the skill of the designer to understand that message and create a visual language to convey it.

Although it is unlikely that many of the identities in this book are aiming to achieve global recognition on the scale of Levi's, IBM or Sony, the fundamentals behind the design and application of a logo remain the same. It provides a visual anchor for any company, whether it be an international corporate or a small local business.

Anatomy of Identity

08>15>>

Corporate Identity –
Its Function and Role>>

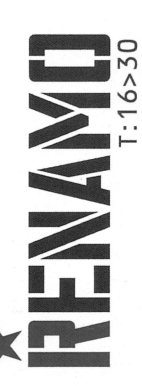

★RENAMO
T:16>30

MAIL
RENAMO LTD
STUDIO HOUSE
MOUNT STREET
NEW BASFORD
NOTTINGHAM NG7 7HX

T:16>30
c/o RENAMO.LTD
PO BOX 5068
NOTTINGHAM
NG7 7HE

COMMS
TEL +44 [0]115 970 1191
FAX +44 [0]115 970 0668
eMAIL ops@renamo.com
WEB http://www.renamo.com

WITH COMPLIMENTS

★ RE NA MO

As mentioned earlier, the idea of corporate identity came about during the late nineteenth and early twentieth century, really matured in the 1950s and has since become an enormously lucrative market for designers. The debate about exactly what defines a corporate identity is ongoing, with other terms like corporate image or corporate communication confusing the issue further.

In short, a corporate identity is the visual statement of a company's role and function and is used to convey a sense of purpose and a set of values. Any company that has a name has to state that name in visual form at some stage. This is more or less unavoidable. The form this statement takes requires decision-making, a decision which is already part of the bigger process called corporate identity. From here a logo, together with the name and guidelines on how these elements should be applied to all material from stationery to products and livery, work together to become a corporate identity.

Writing in 'Corporate Identity, Making business strategy visible through design', Wally Ollins said, "The identity of the corporation must be so clear that it becomes the yardstick against which its products, behaviour and actions are measured."

The term 'corporate identity' is more commonly associated with larger 'corporate' companies. This is mainly because only larger companies can afford to fund the process and pay for the amount of work involved in the development of an identity. In addition to this, it is commonly deemed unnecessary for a smaller company to have such complicated and strict systems of identity, style and application.

For larger companies or organisations, corporate identity is the base element of their corporate culture, developing – with time and marketing – into a brand. The 1997 re-design of British Airways' identity was based on four years' research and two years' collaboration between BA's design team and London-based designers Interbrand. The designers' task was to position BA as a world brand and it did so through a series of 'World Images' rather than a single logo.

However, for smaller companies, particularly those featured on the following pages, such world branding is not required. What is required, however, is a visual language to represent their operation. This can be achieved through a series of photographs applied to a business card, a logotype or a combination of colours. This gives a company or organisation a strong and coherent visual identity that acts as an expression of its personality. It also creates uniformity within a company and sets a standard which all communications must adhere to.

So although both large and small companies require an identity, the designer must be aware that smaller, local companies conduct business on vastly different levels to larger, international companies. The requirements of those clients and the approach to their individual identities will therefore also differ.

As Ollins later points out: "In small companies and in young companies, the management of identity is intuitive. It is a direct reflection of the founder's obsessions and interests. The company is what he or she makes it."

ELENBERG FRASER

ARCHITECTURE
374 GEORGE STREET FITZROY MELBOURNE VICTORIA 3065
AUSTRALIA

TEL +61 3 9417 2855 FAX +61 3 9417 2866
MAIL@E-F.COM.AU WWW.E-F.COM.AU
ABN 97 556 188 726

With this in mind, a smaller company is likely to have a smaller niche audience. Mass appeal is not so relevant and the designer has more freedom to create a logo or name that will appeal to that concentrated audience, who will share similar style and taste.

However, these identities also have the potential to infiltrate and influence our culture to varying degrees as they reach national or international audiences. If a business does grow and become successful on that level, the identity must have the potential to change and grow with that success.

To the advantage of the designer, more and more new and established companies are becoming very aware of the importance of presenting a considered and professional image to clients and customers whatever their level or nature of business. As Simon Needham, co-founder and group creative director at ATTIK recently said, "It is a visual translation of what a company represents to both employees and the external environment, be that business or consumer."

The all important task of transmitting a company's message to its audience is down to understanding how corporate identity operates, as explained here by Mark Diaper, creative director at Berlin-based design agency Eggers and Diaper: "A corporate idea is transformed into a code, the code is transported through a medium to an audience. It then decodes it back, hopefully, into the original idea.

"It is the designer's task to define the most pertinent idea, transform it into the most relevant code, choose and control the transporting medium and ensure that the decoding, which is out of the designer's direct control, results in the acceptance of the original message or idea. This is achieved by understanding the culture and language of the audience."

Left>>Stationery system for Australian spa Retreat on Spring, designed by Ongarato Design.
Right>>Letterhead, compliment slip and business card for ESP Architects. Design by Crescent Lodge.

refresh revive renew reactivate reassure rebuild recapture recover refine recharge recuperate recondition recycle reflect refuel relax regenerate rehydrate reinvigorate release repair replenish revamp rewind respect resplendent restart result revitalize remedy restore reunite reward restate rejoice retreat

Elements of Identity>>

A company identity is something that has to be unique. It is based on a company's history, beliefs, philosophy and on the people who founded or are employed by that company. The designer interprets this and presents the company with a visual identity programme by which it can communicate its philosophy and services to its audience. As I mentioned before, it usually starts by establishing a company name, then developing a mark or logo by which that name can be recognised.

A strap line or slogan is often attached to the name, either stating the company function or voicing a company value or belief as in Nike's 'Just do it'. They do tend to be changed quite often, either to move with the times or to be suited to other environments, such as advertising campaigns or use in another country.

A corporate language is developed, and a tone of voice for literature and correspondence specified. These elements are then put together in a style manual which includes a set of detailed instructions, both written and drawn, advising on how corporate literature, signage, stationery and so on should be applied with colour, typeface and size specifications.

So, once the identity has been developed, style manuals have been finalised and the client is happy, the overall result of that identity has to be communicated to the relevant audience. This is where all the months of preparation, research and design come into their own.

The company will have to be prepared to explain the idea behind the new design, why it was felt necessary and what it signals for the company from management to consumers. Once this has been done and accepted, the identity can go into action and be used in advertising, literature and promotion to create what becomes a brand.

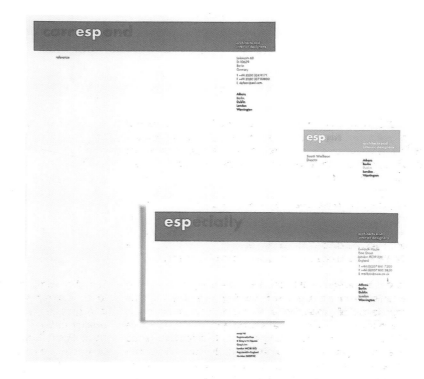

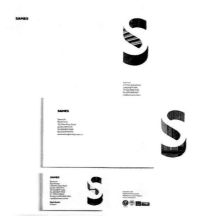

Logos and the
Connection with the Brand>>

A logo is essentially a distinguishing mark designed for a company, product or service and is there to create association and recognition in order to make the reader feel safe and trusting of a particular company. It can be a typographical, illustrative or an abstract mark and sometimes a combination of all these. Either way, it becomes the cornerstone of a company image and one of the base elements of a corporate identity.

Logos communicate corporate values to customers, employees and investors alike. They form a key part of the branding of a company's product or service, so once created, the development and maintenance of the logo is vital if it is going to assist in the successful branding of that product or service.

In some cases, particularly with larger companies, brands and corporate personalities are kept separate, with the company operating a series of what appear to be unrelated brands. Using this strategy enables a company that produces a number of similar products, for instance soap, to promote them under different brand names in the same market without the consumer being aware.

On the other hand, the continuity and association created by applying the same logo to a range of products or services can also be extremely lucrative if executed well. The reputation of a brand established through clever marketing and brand strategy means you can put a well-known company logo on almost any product and those that trust, prefer or who have bought into that brand will buy into it again, whether it is a trainer or airline.

Naomi Klein notes in 'No Logo', "Manufacturing products may require drills, furnaces, hammers and the like, but creating a brand calls for a completely different set of tools and materials. It requires an endless parade of brand extensions, continuously renewed imagery for marketing and, most of all, fresh new spaces to disseminate the brand's idea of itself."

To a certain degree, particularly with certain demographics, the quality of a product, its origin and the policies or politics of the company producing it will never be taken into consideration before purchasing an item. As long as it features the right logo, it does not even matter if it is not authentic. The increasingly common practice of the bootlegging of brands on inferior quality products, is a good example of the saleability of a logo.

People are happy to pay more for a poor quality watch, perfume or jacket, as long as the logo of a famous brand is prominently displayed, regardless of its authenticity. The irony is that the bigger the brand becomes, the more likely it is to widen its franchise and so dilute the quality of the original product on which the logo was first built.

This is all about creating a lifestyle. Through association, a logo on a product can become a personality of its own, expressing a way of living and embodying aspirations that the users identify with. This personality is built by creating an environment for it through advertising campaigns, promotion, sponsorship and association.

Essentially a brand is the visual identity of a related group of products or services that come from one source and are related to the marketplace. It takes continual focus and vision to maintain the success of a brand and much of it is down to making the all-important right decision at the all-important right time.

Above>>Identity for maintenance company Sames designed by HGV Design. **Right>>**Letterhead and business card for homeopathic drug store Perl by Russian designers Prof Design.

ЖЕМЧУЖИНА МУДРОСТИ

фитоаптека
(095) 7282404
(095) 1517808

Guide to Process

16>27>>

fortuneproductions
gillian@fortuneproductions.com
Telephone +44 (0)20 7407 6950
Fax +44 (0)20 7407 6950
www.fortuneproductions.com
409 Cinnamon Wharf
24 Shad Thames, London SE1 2YJ

Gillian Whiting

The Briefing Stage>>

This is one of the most important stages in the process of designing a company's identity. At this point, it is essential that the designer's vision falls in line with the client's objective and that a definite understanding about the aim of the identity is established. The briefing stage is also the time to sound out your client. Establish how they work and look at how best to deal with them. Clients vary. Some are willing to let the designer take full control, whereas others have very definite ideas about what they want. Neither is easier or more difficult to deal with but they do require a different approach.

Jonathan Ellery, partner at design agency Browns, believes that briefing is "all important", adding that eye to eye contact is far better than just a written brief. Generally discussions about the brief involve the whole team: "Clients tend to come to us with a fixed idea in their minds of what is required and tend to leave having to completely re-think it" he explains. "The brief is then re-developed with us and them as a team."

Production company Fortune Productions specified to designers at Browns that their identity had to be both classic and modern, reflecting the culture of their company. Also, they felt that their film work should speak for itself. Browns' solution was to create an understated visual identity with a singular classic typeface – Helvetica Condensed – simply using two colours to differentiate the logotype from the rest of the information on the stationery. "With an emphasis on understated straightforwardness, the identity became one monosyllabic language," explains Jonathan Ellery. "One could say that there is no identity or logo, just a language, and that language becomes the identity."

But understanding the client's brief does not only mean understanding what they think the problem is or what they want, as often this is purely subjective. It is also important to understand why the client perceives certain issues as problematic. Clients may describe attributes of their organisations as problems purely because their competition doesn't have the same attributes. In many instances these supposed problems are actually defining characteristics unique to that company.

Mark Diaper of leading German design house Eggers and Diaper believes that understanding the brief also involves understanding why the brief has been set at all. "It may seem obvious, and is frequently obvious, but it is often extremely subtle," he explains. "In these instances design becomes aligned to psychoanalysis. We listen to the clients' problems, issues of self-image, issues of projection and perception and so on. But, at the same time it's critical to observe the periphery – in other words the issues that the client isn't discussing either for reasons of concealment or because the client doesn't value them," he continues. "Solutions or at least keys to the problem often lie in these areas."

Left>>Fortune Productions identity designed by Browns, London. **Above Right>>**Identity for financial traders Alliance Cbot Eurex designed by USA-based design company Thirstype **Right>>**Labels and business cards for printers Gavin Martin Associates designed by NB:Studio, London.

fortuneproductions
Telephone +44 (0)20 7407 6950
Fax +44 (0)20 7407 6950
www.fortuneproductions.com
409 Cinnamon Wharf
24 Shad Thames, London SE1 2YJ

FRAGILE

Printed in England by
Gavin Martin Associates Limited

PROOFS

Printed in England by
Gavin Martin Associates Limited

Printed in England by
Gavin Martin Associates Limited

DO NOT BEND

Printed in England by
Gavin Martin Associates Limited

URGENT

Printed in England by
Gavin Martin Associates Limited

Printed in England by
Gavin Martin
Associates Limited

Thomas Gerlack

T +44 [0]20 8761 3077
F +44 [0]20 8761 6219
Mobile 07976 927303
E thomas@gavinmartin.co.uk

KGM House 26-34 Rothschild Street
West Norwood London SE27 0HQ

Planning and Research>>

Each company has a message to convey to their potential clients. As a designer it is your job to express the true essence of your client's business or organisation and it is only through extensive research that you can establish what that message is.

The research process should be seen as an opportunity to immerse yourself in the culture of your client's organisation and get to know them. This is also a chance to establish exactly what their requirements are, both now and in the future, in terms of the image they want to present and how and when the identity is to be applied. "This may mean trips to NYC, Paris, the local library, the internet or interviews with staff at all levels," says Jonathan Ellery. "Research is everything, it's the most important part. Be open and soak it all up. We put together large scale visual boards highlighting all of our research. This will highlight positives, negatives, problems, competitors, conversation points," he adds.

Above>>Identity for digital jukebox developers Musicmatch designed by ATTIK, USA. **Bottom Left>>**Business card for The Hive animation designed by Blast. **Above Right>>**Compliment slip for technical textiles company Grip designed by Milch Design, Germany. **Bottom Right>>**Media consultants Workman Partnership had this identity designed for them by Elliott Borra Perlmutter.

richard nelson
senior 3d animator

the hive

37 dean street london w1v 5ap
t.020 7565 1000 f.020 7494 005
richard@thehiveanimation.co.u

grip

Technische
Textilkollektionen

Wir wünschen all unseren Kontakten und Partnern ein gesegnetes Weihnachtsfest und einen guten Start ins neue Jahrtausend.
We wish all our partners and friends a merry christmas and a happy new year.

WP
WORKMAN/PARTNERSHIP
★★★

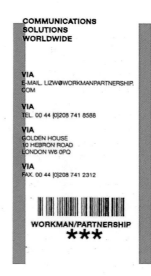

**COMMUNICATIONS
SOLUTIONS
WORLDWIDE**

VIA
E-MAIL. LIZW@WORKMANPARTNERSHIP.
COM

VIA
TEL. 00 44 (0)208 741 8588

VIA
GOLDEN HOUSE
10 HEBRON ROAD
LONDON W6 0PQ

VIA
FAX. 00 44 (0)208 741 2312

WORKMAN/PARTNERSHIP
★★★

Identifying your clients' audience is a critical part of the design process. Finding out details such as their average age, sex, profession, location and so on will be an immense help, however such specific information is not always available or indeed relevant. Consider what their taste is and what appeals to them stylewise. As Needham says: "By setting the right brief, there is better direction as to where to start. Within certain sectors, our experience shows that certain colour palettes work better for instance. Also if you are trying to reach an older demographic, you wouldn't use a techno font."

London-based design agency Elliott Borra Perlmutter (EBP) was asked to create an identity and stationery (right and below) for international media consultants, Workman Partnership (WP). Although a relatively small company WP operate around the world and it was an essential part of the brief that this be made clear within their corporate identity.

Designers at EBP have played with images of airline luggage security tags, complete with bar codes and abbreviated letters. It not only makes for a bold and distinctive identity but also uses a visual language that is familiar around the world.

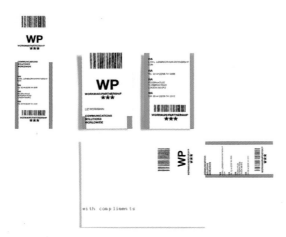

with compliments

Developing Ideas>>

With the brief defined and planning and research completed, designing and developing an identity can begin. This evolutionary process will see one idea spark another and although initial thoughts on design approach are not to be dismissed it is good to push ideas to the next level.

This is the conceptual phase and is therefore a time to concentrate on the specific message that will ultimately be communicated to a certain audience in an engaging, informative and memorable way. Different designers have different methods or systems when developing ideas. International design agency ATTIK has devised a system it uses when carrying out research and preparing for the design of an identity that revolves around five A's; audit, articulate, apply, announce, and adhere.

There is no 'method' for creating an identity, but whether you are at the beginning of your design career or have been in the profession for a number of years the same primary considerations apply. It must be representative, and by using the brief and research consider all possible images or icons that could represent the client's business.

This may include plays on the name (if one is established at this stage), the nature of the business, where it operates and who its audience is. Berlin-based Eggers and Diaper created what seems like an abstract symbol to represent Anja Gockel, one of Germany's leading young fashion designers (see above). However, initial drawings were a series of cockerel illustrations, a play on her surname, which translated means 'cockerel'.

The identity must also be visible. Depending on the client's business the identity will often have to stand out in cluttered and competitive environments. This was a specific requirement by one of Italian designers BCPT's clients, College 4 U (see pages 54–55). They required a logo that would stand out from other institutes' logos and capture potential students' interest in the college. For whatever reason the logo may be required, it must be memorable and easily recognised.

Creating a timeless identity is crucial. Although the larger corporations seem to enjoy a complete identity re-launch every few years, smaller companies will not find this as necessary and are unlikely to want such revamps as often. For this reason it is advisable to create an identity that does not follow current trends and has longevity.

Above>>Identity for German fashion designer Anja Gockel designed by Eggers and Diaper. **Bottom>>**The stationery of ICM, Dutch dealers of photography for collectors, designed by KesselsKramer.

shoot 5 Church Studios T 020 7267 4333
 Camden Park Road F 020 7485 4111
 London NW1 9AY www.shootproduction.com

shoot 5 Church Studios T 020 7267 4333
 Camden Park Road F 020 7485 4111
 London NW1 9AY www.shootproduction.com

Registered Number 4151207 Shoot Production Limited trading as Shoot Registered in England & Wales

Technological advances raise new questions in the development of an identity and its potential application. Today, many small businesses have websites or produce CDs, so will also want to apply their logo to those digital mediums. It is important to establish these details at the start of the project as they may well influence creative options and decisions. Even if a web project wasn't in the initial brief, it should be considered in the development stages.

London-based designers Tonic were asked to create an identity and website for production company Shoot. The three main aims when designing the identity were to ensure that it reflected the company's experience and creativity, it appealed to its international advertising and fashion client base and also that the logo could translate to the company's website. The square format logo has now become the main interactive element of the website navigation.

To use already established corporate colours when re-designing an identity, or choosing a company's corporate colour when designing its first identity, is usual. However, it is worth remembering that the more colours you use, the more expensive the printing job will be. After many years of use, the British Broadcasting Corporation recently removed three coloured lines from its logo saving thousands of pounds in printing and application costs.

Above>>Identity designed by Tonic for production company Shoot. **Bottom>>** Business card and letterhead for central heating engineer Gary Heaton designed by NE6 Design.

HEAT ON
Gary Heaton central heating engineer

HEAT ON
Gary Heaton central heating engineer

HEAT ON
Gary Heaton central heating engineer
141 Cornwall Avenue Blackpool Lancashire FY3 9QS
T+F 01253 357606
corp registered

Presenting to the Client>>

Depending on the type of designer-client relationship that has been established, the flexibility, or not, of the original brief and the number of people present at the presentation, the course of the identity from here will vary from client to client.

Before starting a presentation, remember this: the client is making an extremely important long-term decision and so every effort should be made on the part of the designer to ensure that the presentation is treated as a serious matter and that any issues or concerns are raised and discussed.

Do not rely solely on the design, however exceptional you or the client think it is. It is the speech that is given explaining how this design was arrived at and the reasons behind all the elements of the identity that those present will want to hear. It will become a designer-client debate about the potential success and effectiveness that the identity will have. I mentioned earlier that there was no 'method' for developing an idea. The same applies when presenting an idea; all situations are different and will require different approaches. However, there are certain strategies that should be borne in mind when conducting such meetings.

It is good to start by summarising the brief. It will remind the client what was asked for in the first place, what points were specified, what ideas they had and so on. Next, explain how you addressed the problem, what steps were taken to solve the issues and needs specified in the brief, and why.

Thirdly, you must present the idea or ideas. The final visuals used at this stage should be as close as possible to the finished job. It is usual for a designer to present a client with around three different options, although this is not always the case. With some clients it is simply not necessary, as was the case for a particular client of UK designers Johnson Banks. Michael Johnson, principal at Johnson Banks, felt that the requirements for an identity designed for PR company client Kushti were established and understood to such a degree that he presented them with only one idea (see pages 42–45).

Above>>Compliment slip and business card for Polish Zootechnical Institute designed by Piotr Karczewski at Studio PK. **Bottom>>**Dutch theatre group Aluin had this identity designed for them by Anker XS.

pearl

geoff lindsay

pearl restaurant+bar pty ltd
631-633 church street
richmond 3121 victoria
australia
telephone +613 9421 4599
facsimile +613 9421 0908
mobile 0438 227 448
www.pearlrestaurant.com.au

This Page>>Business cards and compliment slip designed by Ongarato Design, Australia for Pearl restaurant and bar.

However, German designers MetaDesign presented two ideas to their client, The Glasgow School of Art (see pages 90–93). In this instance, the decision as to which identity should be used was left up to the client. Once the decision was made no changes were necessary and the designers were able to go ahead and finalise all aspects of the project.

When showing images, make sure you explain them. Highlight elements of the design that you feel are of particular importance to the client or that relate to a specific point in the brief. Explain why you have chosen to use certain colours, imagery, if there is any, and of course the type. Also be honest, bring to the client's attention any aspects that may possibly cause problems, so it is clear what they are being asked to accept.

Finally, outline the recommended next steps. What is required will depend on how satisfied the client is with the design and if changes are necessary. For the majority of the projects featured in this book, the changes required at presentation stage were generally fairly easily manageable. This was probably due to the fact that most of the featured companies were small businesses where there were often only one or two people with whom the decisions lay, so they could be made and implemented quickly.

However, with larger, especially global, companies, you are likely to find that many more people are involved in the process, and it will take longer to finalise decisions. During the presentation be prepared to offer alternatives to aspects of the design. This may include colour, so have other examples ready to show the client; or type, so again have alternative typefaces or sizes to present them with.

Above all it is extremely important to remember at this stage that the client expects to be instilled with confidence, see something they like and leave the presentation feeling good. It is therefore the responsibility of the designer to prepare for all outcomes, good or bad, organise alternative options and have a solid explanation ready when beginning a presentation.

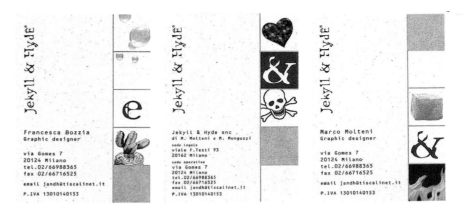

Managing the Application>>

The effective follow-through of an identity design is as important as actually designing the identity in the first place. It is wrong to think that once an idea has been presented and accepted, there is nothing more for the designer to do except organise a printer.

It is part of the designer's remit to ensure that the consistent and correct application is organised for a corporate identity programme, however big or small. This usually starts with printing the stationery set but can also include application onto a website, vehicle liveries, packaging, clothing and so on.

Depending on what the budget allows, the client should be provided with a style manual or at least a letter layout template. The Grids and Guides chapter of this book has an explanation and examples of these letter layouts and some style guides.

If the identity is a re-design of an old identity then obviously the new one will have to be phased in. This can be a major operation if the client works internationally, like British Airways or Philips, the Dutch electronic giant, and it is virtually impossible to change everything at once – the process will continue for many months.

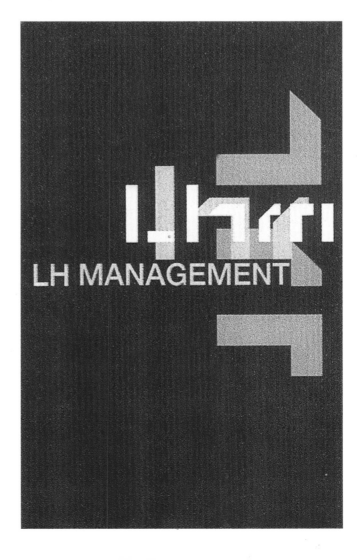

Above Left>>Business cards for and by Italian graphic designers Jekyll & Hyde. **Bottom Left**>>Stationery for Lisa Horan Management designed by Moot. **Above**>> Stationery designed by Prof Design, Russia. **Bottom Right**>>Stationery for Little_i book publishers deigned by Graphic Thought Facility, UK.

However, many larger global companies require maximum impact on launch of a new identity and use it as a catalyst for change, as was the case with BA. In these situations, identify what is most important for the company to communicate and apply the identity to that first. Press release kits, vehicle liveries, advertising and stationery could be launched together with other, less crucial, items following later. If it is a newly launched company, then they too will probably choose to phase in applications due to costs, and, depending on the nature of the business, begin with stationery or a shop signage. The designer should provide the client with information about costs, so that they are able to decide where to apply the identity and at what stage. This budgeting process requires great skill and consideration and is best decided upon by both designer and client.

Essentially, managing the application of an identity, from printing the business card to maintaining a good working relationship with the client, should be controlled from a central point so that consistency is maintained. It is only then that a corporate identity begins to establish the unity that is required to make it successful and effective. Companies grow and change and employees come and go, the corporate identity is there to maintain some form of continuing but changeable consistency.

Work

28>109>>

Imagery>>

The use of imagery to create a visual language for a company has become increasingly popular. It may be used as a primary or secondary language but either way, an image will add colour and strength to any company's envelope, business card and so on. This is nothing new; since the earliest recordings of examples in the fifteenth century, identities and the material they have been applied to have carried illustration or imagery of one sort or another.

Just as effective in black and white or colour, the use of imagery can attract increased attention or interest. The type of photograph or illustration used is dictated by contemporary fashions or trends and the limitations of the printing process. At its most basic the company letterhead will carry the company logo, but it is up to the designer to add that extra character by using hand-rendered illustration, photography or typographic illustration.

In some cases, the importance of clean white space will see imagery being applied to the reverse of a letterhead or business card rather than the front. This applies to the identity of London-based art direction and design agency Big Active (see pages 32–33) where an illustrated image of a couple arm-in-arm features full bleed on the reverse of all communications as a secondary identity.

Imagery may come from photo libraries, (there are a growing number of specialist libraries), illustrators, either in-house or commissioned, found imagery, computer generated images or specially commissioned photography. UK-based design agency HDR has used a series of strong images on its own stationery set (below right). The images are of their own studio and working environment both inside and out, and have been used to inform clients and communicate with them, in a slightly ambiguous way, about HDR. The designers also felt that the use of imagery was a good way of creating interest and making people think about them and what they stand for. Three different stocks have been used to further contribute to the overall experimental and interesting image of their company; Neptune Unique 120gsm, Redeem 100% recycled 70 gsm, and Offenbach Bible 50gsm (which is worth noting does not go through a laser printer).

Above Left>>Right Way Up Photography letterhead by Mytton Williams. **Bottom Left>>**Right Way Up Photography business cards designed by Mytton Williams. **Above Right>>**Letterhead for 4 Africa by Dutch designer SWIP STOLK. **Bottom Right>>**Stationery for and by HDR Design.

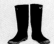

HDR's business cards operate as concertina fold-outs, and again featuring strong imagery – for example sky and utilitarian objects. Each designer can choose whether or not to hand-write their name or use the rubber stamp created especially for them. Hans Dieter Reichert at HDR Design explained the concept: "Our intention with the visual identity and the way that it appears is to reflect the company," he says. "That is the way the company works, structured, clear, analytical, pure typographic but also creative, visually poetic, experimental and image conscious. All images reflect our belief in nature and technology and are connected or linked to design."

Designers at UK company Mytton Williams have used imagery as a secondary language on client Right Way Up Photography's stationery. The type-only logo sees a play on the company name with the word 'Photography' set upside down below the rest of the type in a lighter colour text hinting at reflection. However, it is still clearly readable even at a glance. Six different black and white images, including a pair of wellington boots and an ice cream, have been applied to the front and back of each business card the right way up on one side and upside down on the other.

Imagery can be very powerful and used in some cases for fun and other cases to get across a serious message. Dutch designer SWIP STOLK has used a stark, raw image on the reverse of a letterhead for 4 Africa, a non-profit organisation that finds some of the best photographers, designers, writers, dancers and so on in Africa and represents them. The logo refers to the Dutch magazine logo, also designed by SWIP STOLK in 1993, and has been applied using foil and the debossing method. By using a secondary visual language, either to raise a smile from the reader or get a serious message across, imagery is a great way to illustrate a company ethos, function, personality or message.

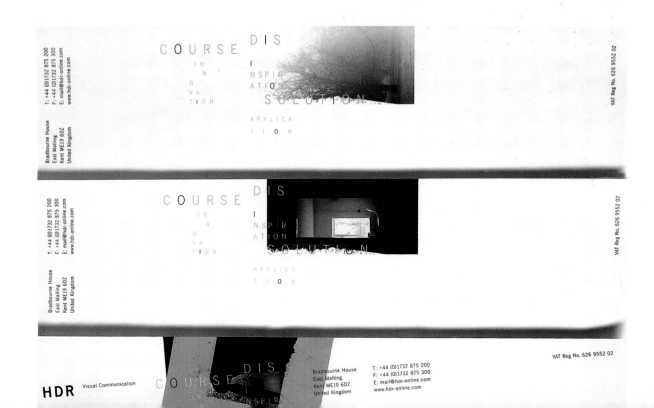

Client>>Big Active
Design company>>Big Active, UK

Brief>>Big Active incorporates Big Active Art Direction and Design and Big Photographic, creative management for illustrators, commercial artists and photographers under the umbrella of BigActive.com. Founded in 1988 by designer Gerard Saint and two others, Big Active have been responsible for art direction of Nova magazine, Bassment Jaxx album covers, Ben Sherman advertising and design in Another Magazine, while Big Photographic represents artists including Simon Henwood and Jasper Goodall. The girl and boy logo was originally created in 1998 but was updated earlier this year.

Solution>>Creative Director Gerard Saint created a logo that is not directly related to design but that appeals to the company's client base: largely record companies, bands, magazines and advertising agencies. "We liked the idea of coming together, something sexy," explained Saint, "an embrace about to lead somewhere. Are they going to dance? Exchange numbers? Do drugs? Have sex? It's open ended and more of a lifestyle thing." The illustration has been applied in a variety of ways to the stationery. The Big Active letterhead features the illustration full bleed on the reverse, while the Big Photographic letterhead sees a smaller pink to orange image of the couple at the head of the paper in order to differentiate it. Postcards, compliment slips and stickers feature the girl and boy logo in a variety of colours but the business cards have a different theme. Gerard Saint's business card features a photograph of him wearing an Arnie mask with a corporate hostility T-shirt.

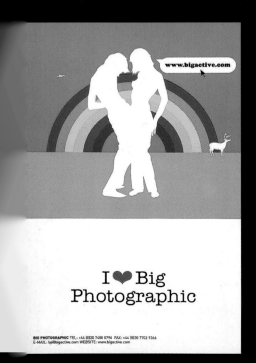

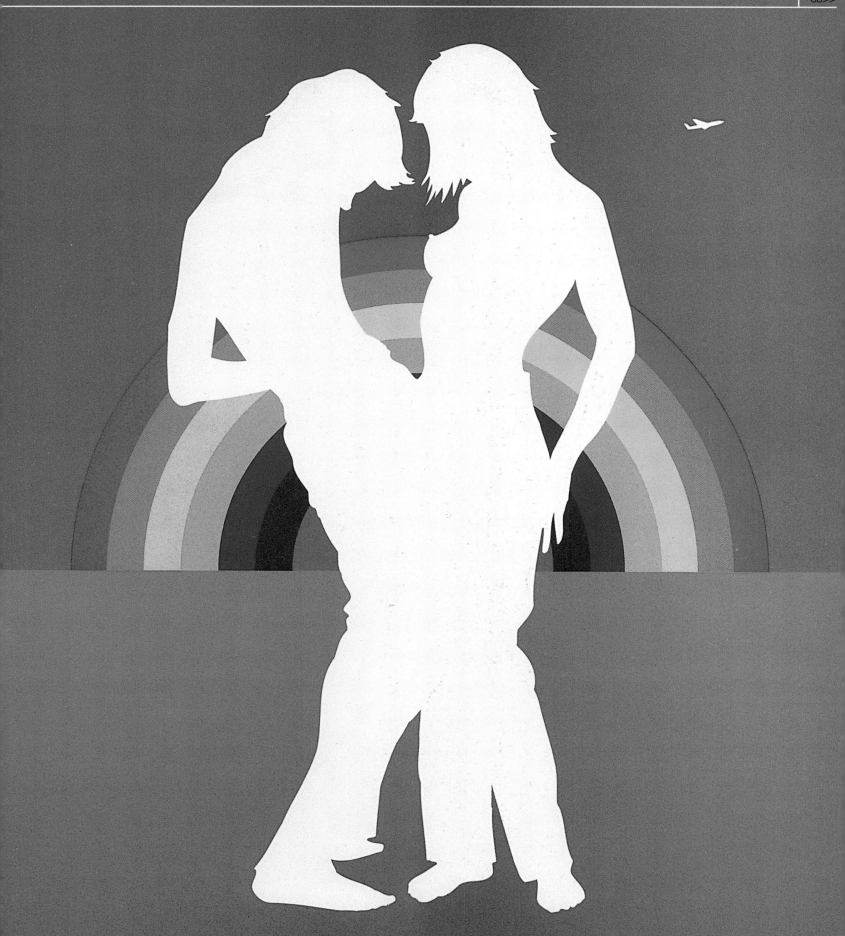

PRODUCT OF GOD. MANUFACTURED IN THE UNITED KINGDOM.

Client>>Lucas van Doorn
Designer>>KesselsKramer, Holland

Brief>>Lucas van Doorn is an Amsterdam-based model maker working mainly for photographers and directors in the advertising and film industry. Doorn met designers at Amsterdam creative agency KesselsKramer through mutual client 55 DSL, and asked them to design him an identity. At the time, he was running ads in specialist magazines that showed him in his workshop holding up a piece of paper with the tagline 'Ready when you are mister Spielberg'. Obviously this concept was not suitable for application onto stationery and besides, he was looking for an interactive concept not just a logo on paper.

Solution>>Pim van Nunen, art director at KesselsKramer created an identity and stationery set based on Doorn's profession. "I wanted to give people the opportunity to build something," he explains. "So they could enjoy and feel how it is to be a modeller, and feel like a kid again." Numbered dotted lines on the letterhead provide guides to build a paper aeroplane or a paper boat. "This was a bit of a problem, making sure that the lines where in the right place," says Nunen. "To solve this problem, I had to waste a rainforest." Printed in red to give the design a technical and instructional feel, the colour contrasts well with the black Din Mittelschrift typeface allowing it to remain clear and readable. A lighter than usual stock has been used for the business card so that it can be folded.

Lucas van Doorn

Modelmaker

FAKTUUR

Cliëntnummer

Faktuurnummer

Ordernummer

Faktuurdatum

Nota voor

Voor het vervaardigen van

Inclusief materialen

19% BTW

Totaal

⑥ → ← ⑦

Bloemgracht 126, 1015 TP Amsterdam, tel 020-4223169, fax 020-6224035 ABN-AMRO 47.22.50.027.
BTW nr. 1131.23.280.B.01, K.v.K. Amsterdam 33181187. Betaling binnen 30 dagen na faktuurdatum, onder vermelding van het faktuurnummer.

Lucas van Doorn
Modelmaker

⑥ → ← ⑦

Bloemgracht 126, 1015 TP Amsterdam,
tel 020-4223169, fax 020-6224035.

Client>>Peter Sterling
Design Company>>Mattmo, Holland

Brief>>The brief was fairly straightforward. Amsterdam-based design agency Mattmo were asked to create an identity for the Peter Sterling photographers agency. However, convincing the client that the design solution path taken was the right one was not so easy. Operating as a high-end international fashion photographer's agent, with offices in Amsterdam and Paris, the client's main concern was that the identity would fit in with that environment.

Solution>>Paul van Ravestein, art director at Mattmo wanted to use light within the identity as it is essentially the essence of photography. Inspired by a number of short films that he had recently made in Tokyo, Japan, where neon light is very popular, Ravestein convinced the client to make a neon light of his name. This was then photographed by one of Holland's top photographers, Jerome Esch, to form the main logo that has been applied in some form to all communication material.

From this, a visual language emerged, and designers created a series of neon blue colour-based images representing the atmosphere created by light and the effect of photography. This collection of images was then applied to the stationery, with each different item featuring a unique image. Completed in late 1999, the identity was something of an experiment with designers not entirely sure where things were heading in the beginning. The result is a contemporary and unusual identity that uses cleverly adapted imagery.

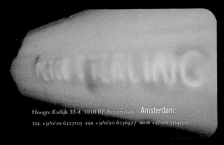

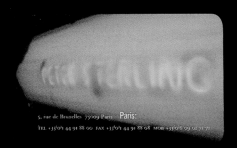

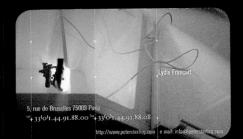

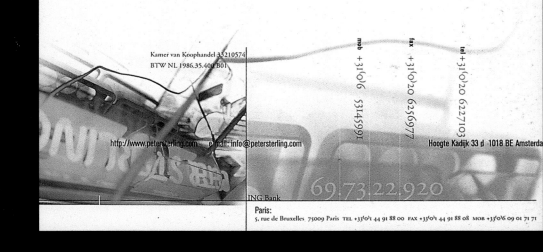

Kamer van Koophandel 33210574
BTW NL 1986.35.400 B01

mob +31(0)6 53145991

fax +31(0)20 6256977

tel +31(0)20 6227103

http://www.petersterling.com e-mail: info@petersterling.com

Hoogte Kadijk 33 d 1018 BE Amsterda

ING Bank 69.73.22.920

Paris:
5, rue de Bruxelles 75009 Paris TEL +33(0)1 44 91 88 00 FAX +33(0)1 44 91 88 08 MOB +33(0)6 09 01 71 71

lient>>Propergear
esign Company>>Bobbett Design, UK

 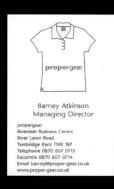 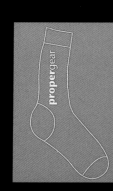

ef>>Set up in 2001, Propergear produces customised
broidered items. It distinguishes itself in the marketplace
specialising in short-runs, targeting individual consumers,
well as businesses and organisations. The company
ked Bobbett Design, UK, to produce an identity that would
scribe the specialist nature of Propergear's business and
peal to its broad customer-base which ranges from moth-
who need their children's school garments embroidered
sports teams. They also wanted Propergear's willingness
handle one-off and small orders, and to apply embroidery
an infinite range of products, to be reflected in the identity.

Solution>>The corporate colours, orange and green,
combined with white line drawings are the unifying elements
of the Propergear identity. Rather than creating one fixed
mark for the company, Bobbett has designed an identity
'family'. Each item of stationery and piece of collateral
features a Propergear logo applied to a product. What this
product is varies from application to application, giving the
stationery set variety.

There are, for example, five different permutations of the
company's business card: a logo and tie; logo and shirt; logo
and cap; logo and sock, and logo and rucksack. This iden-
tity has provided the client not only with a logo, but a versatile
system of graphics. At any time, new items can be added to
the range of illustrations, or specific items can be tailored to
specific markets, i.e. polo shirt items for sports teams.

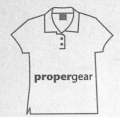

propergear

propergear
Riverside Business Centre
River Lawn Road
Tonbridge Kent TN9 1EP
Telephone 0870 607 0713
Facsimile 0870 607 0714
Email sales@proper-gear.co.uk
www.proper-gear.co.uk

Client>>hot-dna
Design company>>Peter Heykamp, Holland

Brief>>Hot-dna is a Dutch advertising agency. It has a strong philosophy and statement of principles, which is to focus on the individual client, understanding their advertising requirements at the core level. Dutch designer Peter Heykamp was asked to design an identity for the agency that would clearly translate the philosophy of hot-dna.

Solution>>From the beginning Heykamp was interested in focusing on the name of the company and looked at ways to bring it alive. His initial thought was to show the DNA of every individual director of hot-dna but found that this was not possible. He contacted a professor at the Erasmus University in Rotterdam and was informed that it is not allowed by law to visualise the DNA material of one individual.

hot-DNA.COM

stadhouderskade 129 1074 AW amsterdam]
T 020 4712057 F 020 4712058 E lisa@hot-dna.com

Heykamp suggested that he mix the genetic material of the three directors to create another image, that way one can not see which DNA strings belong to which director. The reverse of the letterhead shows the entire image of the three directors' DNA results. This image has then been cropped and applied to business cards and other items. As well as a direct reference to the company name, Heykamp also wanted to use images of the directors' DNA on the stationery to show the honest, nothing to hide mentality of the company. As the address sticker shows, the three directors went to their family doctors to give a blood sample, and the sample test tubes are shown in a photograph on the back of the letterhead. Platelet and Lettergothic typefaces were used and printed on Consort royal satin stock.

Imagery Process Interview
Client>>Kushti Consulting
Design company>>Johnson Banks, UK

Brief>>Kushti Consulting is an all-female PR and communications company based in London. This newly launched company required an identity, so they approached UK designers Johnson Banks and asked them to create a logo and stationery set that would sum up 21st-century woman. Despite the tight budget, the identity still had to be fun, interesting and effective.

Developing the Identity>>Michael Johnson, creative director at Johnson Banks, knew the client well before being asked to design the identity and so was fairly confident about the desired style and tone. From early on, the design was visually strong and quite daring with a 'ladette' feel to it – a reference to the personalities of the Kushti employees.

It was decided that bright, bold photography would play a big part in the identity and a number of image ideas were thought of and tested for suitability. On presentation to the client, not all of the ideas made it through. There was an image of a set of pink fluffy handcuffs that was dropped and the make-up penknife eventually featured (below) originally had a cocaine spoon on it as well.

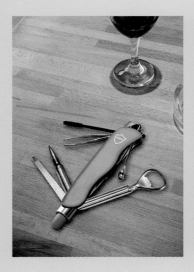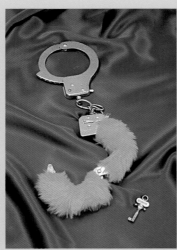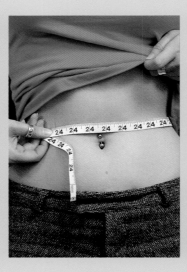

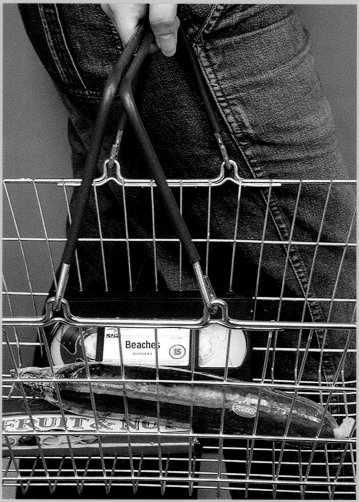

The idea of creating six different logos was really intended to compliment the various images and add another dynamic to the overall identity. "We liked the idea of the photos and then it occurred to us that the vernacular of each photo would work even better if we could change the logo each time," explained Michael Johnson, "so we did, against commonly held business logic."

Designers at Johnson Banks spent a long time working on the identity before showing the Kushti girls and no other ideas or approaches were created as Banks felt that the image-led design was the best way to go. Also, because of the close and trusting relationship with the client, it was not felt necessary to have a back-up of support ideas or options.

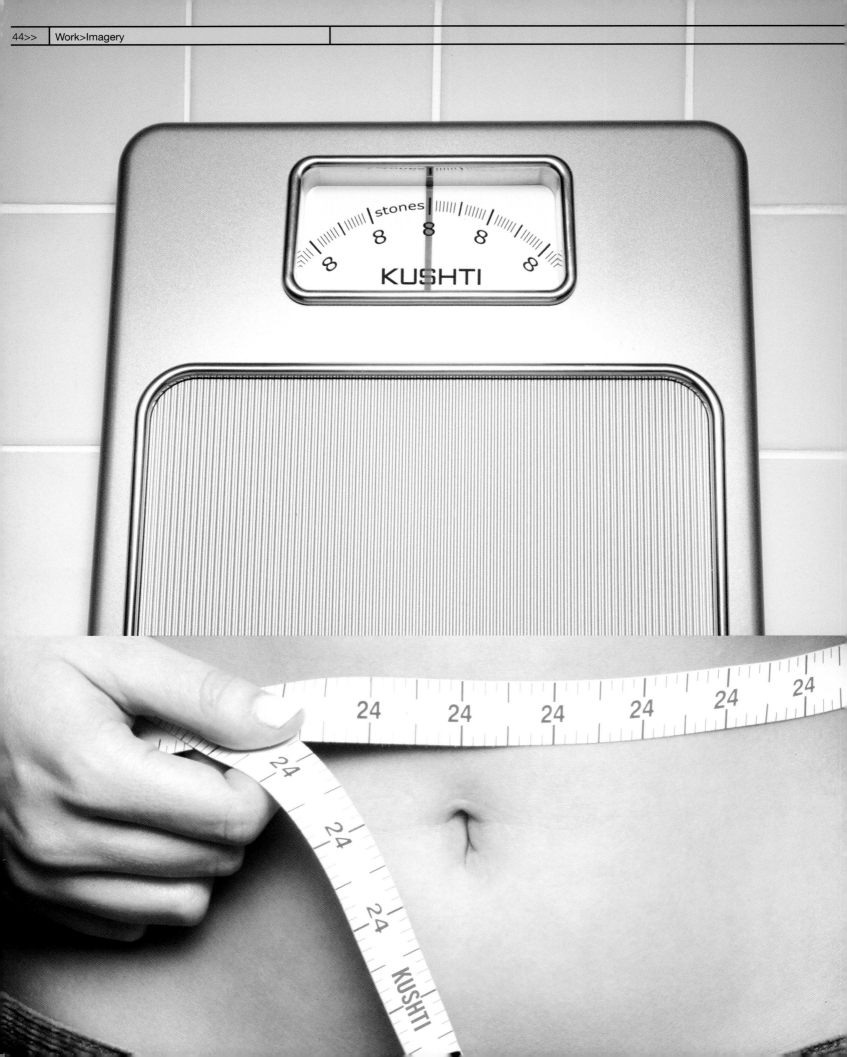

Kushti

Liz Vater Big Cheese

Kushti Consulting
17–19 Bonny Street London NW1 9PE
telephone 0207 485 7440
fax 0207 482 3553
mobile 07779 228 969
email liz@kushtinet.com

Solution>>Banks finally created a total of six different Kushti logos all in bright pink. Each of these logos has been applied to the stationery with six different full bleed photographic images on the reverse. This has given each member of the Kushti team six different business cards and the choice of six letterheads and compliment slips. Each of the photographs on the reverse features one of the Kushti logos.

Banks wanted to use photographic images, taken by London-based photographer David Sykes, that summed up what being Kushti – a derivation of the East End London slang for sorted – meant for an all-girl communications company. The chosen images – a slim waist, a low weight and a make-up penknife – were intended to be somewhat

seedy, to force a double take on the part of the viewer, and also, as requested, to sum up 21st-century women.

The penknife was created by model maker Wesley West and is far larger than it seems. Once photographed and transferred into Photoshop designers reduced it in size and placed it on the table image. The body copy is Univers but all the logos were designed separately and with different typefaces.

The identity has been dubbed as 'Sex and the City' stationery for the modern woman. Filling the requirements of the brief – to be fun, interesting and effective – Johnson Banks has created a memorable and thought-provoking identity.

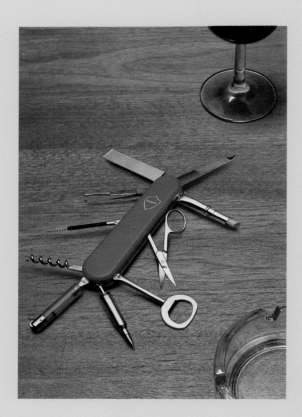

Kushti Consulting
17–19 Bonny Street London NW1 9PE
telephone 0207 485 7440
fax 0207 482 3553
email info@kushtinet.com

Kushti Consulting
17–19 Bonny Street London NW1 9PE
telephone 0207 485 7440
fax 0207 482 3553
email info@kushtinet.com

KUSHTI

Logotypes and Symbols>>

The use of symbols, signs and icons to represent an idea, an activity or object, has been with us for hundreds of years. The creation of simple signs was man's first attempt to communicate using drawing or imagery, rather than language. Today, these symbols often form the basis of a brand or corporate identity and can also be used as a company trademark. They can be pictorial or abstract and can be used in commercial, political or cultural contexts, but what makes them special is that they work internationally – no language is necessary.

Similarly, logotypes, although type-based, become company symbols and are recognised and associated with a particular company. Logotypes can also be used as the basis for a trademark. The United States Patent and Trademark Office defines a trademark as "a word, phrase, symbol or design, or combination of words, phrases, symbols or designs, which identifies and distinguishes the source of the goods or services of one party from those of others" (see Law section, pages 154–155 for further information).

Some of the more iconic logos of recent times are Westinghouse's, created in 1959 by Paul Rand, architect Eliot Noyes, designer and photographer Herb Matter and Charles Eames; the Quaker Oats logo, re-designed by Saul Bass in 1970; and Henrions KLM logotype of 1964.

The careful choice of typeface is essential when designing a company logotype. Depending on time and budget, some designers choose to create a bespoke typeface, sometimes because no existing typeface is suitable, or to reassure the client that their identity is unique.

Using a secondary but complimentary typeface is common when designing logotypes, and mixing and contrasting serif and sans serif, bold and light and condensed and extended typefaces, creates interesting all-type logos.

Christian Kusters at CHK design has created a logotype for London-based contemporary art gallery Milch based on a glass container. The word 'milch' means milk in German so the reasoning is two-fold: firstly to refer to the word milk and drinking it out of a glass and secondly to present the idea of a gallery as a neutral transparent container.

Kusters has used the sans serif Univers typeface in an attempt to create an overall harmony between the two elements, glass and type. The design of Univers was based on the idea of a square and so too is the shape of the glass that Kusters has created to surround the company name. The combination of the two clean, simple and bold elements make for a neat, compact identity, ideal for a contemporary London art gallery.

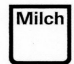

2–10 Tinworth Street
London SE11 5EH
Tel: +44 (0)20 7735 7334
Fax: +44 (0)20 7735 7331
Email: milch@easynet.co.uk

Registered Charity No: 1067382

Above>>Milch logo by Christian Kusters at CHK Design.
Right>>Business card and compliment slip for and by Austrian designers Nofrontiere **Bottom Right>>**Logo for and by London designers TheFarm.

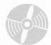

ALI SZADECZKY
VORSTANDSVORSITZENDER
NOFRONTIERE DESIGN AG
ZINCKGASSE 20-22
1150 VIENNA, AUSTRIA
T +43 (1) 98 55 750
F +43 (1) 98 55 750 3
A. SZADECZKY@NOFRONTIERE.COM

Designers at London-based agency TheFarm have created an organic, fluid-like logo shape with accompanying functional Swiss letterforms for their identity. Using a farm-like colour palette of muddy greens set against the clean white background, the identity is a play on the agency's name and the urban environment in which it is situated. "I like the idea that if someone received a letter from us, the logo, name and colours on the address label would raise questions and inherently provoke interest in what TheFarm is," explained Fergus Partridge, partner at the company.

Originally, Austrian design company Nofrontiere used a fan symbol as its company logo. Created in 1990, the designers liked the fact that it was a real object, a human-made wind maker, but also because they felt it acted as a strong visual representation of Nofrontiere. They wrote in their first book, "it transforms one form of energy into another, the same way we do everyday with our work."

The following years saw the fan abstracted to the propeller symbol (above) that they use today. In a recent re-design of their identity Nofrontiere has used the propeller randomly on the stationery, and as a nearly vanishing element, blind embossed on the business cards and in various colours on their letterhead.

theFarm.

Ian Wallis

The Prince of Wales
59 Barnet Grove
Bethnal Green
London E2 7BH

theFarm.

Client>>Tugboat
Design company>>Tugboat, Japan

Brief>>Tugboat is an advertising agency based in Japan whose clients include Sky perfect TV and East Japan Railway. It is a small but well-known agency both in Japan and internationally, and launched sister company Tugboat2 in early 2001. It is an extension of Tugboat and both teams work together but Tugboat 2 focuses more on international business. Tugboat art director Seijo Kawaguchi created the original identity in 1999, while the more recent Tugboat2 work was designed by Kengo Kato, also an art director at Tugboat.

Solution>>Kawaguchi has created an understated logotype for Tugboat based on the Frutiger typeface, which is complimented by the strapline 'We'll pull you where you want to go'. Printed on thick weave paper, its simplicity and clean design makes for a very attractive and classic stationery system. The business card is unusual in that it features all four employees' names on it both in Japanese and English. A box is placed next to each name, which is ticked by the relevant person. Kawaguchi chose this approach because he wanted to show the four members as one strong small unit instead of four individuals, as each member of original Tugboat were already well known and respected in Japanese advertising.

When Tugboat relocated offices, the business card was attached to a photograph and a postcard featuring a map of Tokyo. On the map, a small image of a tugboat indicated exactly where the offices were. In addition to this, a sticker card was used for a mail out when Tugboat2 was launched in January 2001. Pulling off the address or name stickers reveals an email address or a Happy New Year greetings message.

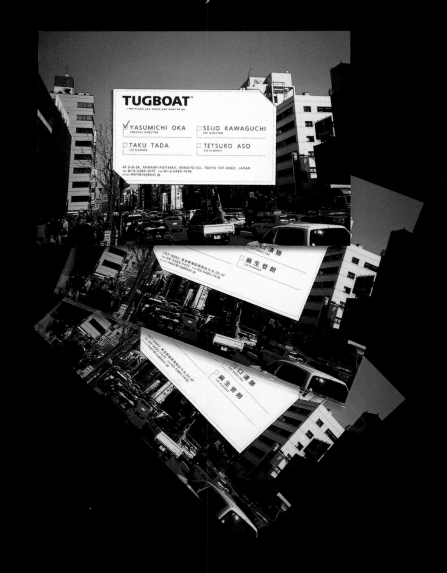

TUGBOAT™
· We'll pull you where you want to go.

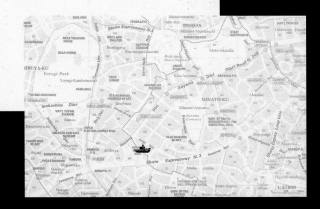

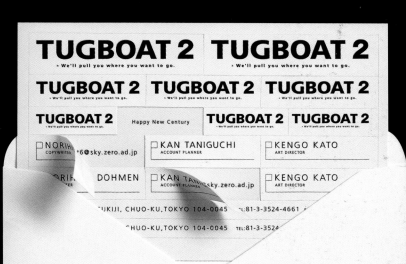

Client>>Munich Online
Designers>>Milch Design, Germany

Brief>>Munich online is a web-based listings magazine for Munich and the surrounding area. Aimed at an urban, web-literate audience, it offers up-to-the minute coverage of events in the region. Local design agency Milch were asked to develop a branding and corporate design for Munich online that could be applied across the magazine and all its communications from stationery to flyers, posters and infoscreen presentations (an entertainment and advertising system in subway stations). Crucially, it had to appeal to potential advertisers and local partners, as well as to its readers.

Solution>>A simplistic logo, based on the combination of a computer key and a speech bubble, has been created to allow easy and inexpensive reproduction across various mediums at various sizes. Upside down, the outline of the logo also suggests a pointing hand. The design successfully combines the client's desired connotations of Internet, communication and Munich in a style that appeals to both target readers and potential advertisers. Large monochrome areas, white spaces and the use of clear Berthold Imago type are the decisive factors of the corporate design. The application of the identity onto the press release sees the logo enlarged to fill the page. Additional materials, including postcards, feature a secondary visual language created by using full format contemporary photography.

munich online

mauerkircherstr. 26
81679 münchen
t 089.99.72.84.30
f 089.99.84.84-344
munich-online-info@usa.net
www.munich-online.de

geschäftsführer:
martin schmitz
dietmar beyer

bankverbindung:
hypovereinsbank
blz 700 202 70
kto 44 909 790

das neue munich online ist ein projekt der score medien-, dienstleistungs- und handelsgesellschaft mbh i.gr.

pressemitteilung

munich online
redaktion kaulbachstr. 38 80539 münchen t 089.330.66-340 f 089.330.66-330
mol-redaktion@medienhaus.net www.munich-online.de

ein projekt der score medien-, dienstleistungs- und handelsgesellschaft mbh
mauerkircherstr. 26 81679 münchen t 089.99.84.84-0 f 089.99.84.84-344
bankverbindung: hypovereinsbank blz 700 202 270 kto 44 909 790

Client>>One 4 Two
Design Company>>KesselsKramer, Holland

Brief>>Two years ago, the Dutch music and sound design company One 4 Two approached KesselsKramer with a commission to develop their new identity. The brief was fairly straightforward and open, One 4 Two simply wanted music and sound to somehow be visualised within the identity.

Solution>>The design solution of the creative director at KesselsKramer, Erik Kessels, was inspired by an old box of the sixties children's toy, Spirograph. This toy consisted of a series of plastic circles and shapes with ridged edges that created intricate designs when a pen traced the path of the small shape as it rolled around the inside of the bigger circle (like cogs).

Different coloured biro pens were used to create elaborate symmetrical patterns and shapes like those used in the design of the One 4 Two identity. Kessels has used lowercase Univers Condensed Bold typeface in a layout that draws on design elements from the Spirograph technical manual. The stationery has been printed on recycled stock and Kessels also applied original Spirograph drawings made by his girlfriend when she was seven. "To me, visually, these [shapes] have a lot of connection with One 4 Two's sound and equipment," explains Kessels. "It was designed on instinct, in about 45 minutes."

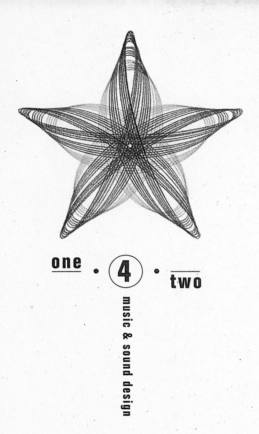

one . **4** . two

music & sound design

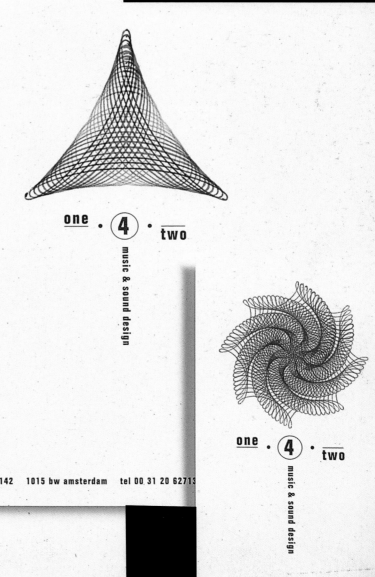

one . **4** . two

music & sound design

one . **4** . two

music & sound design

herengracht 142 1015 bw amsterdam tel 00 31 20 62713

engracht 142 1015 bw amsterdam tel 00 31 20 6271377 fax 00 31 20 6387075

Client>>College For You (C4U)
Designer>>BCPT, Italy

Brief>>College For You is a professional college in Italy that specialises in information and technology courses, particularly web applications. However, one point that sets it apart from other institutes is that the course structure allows students to manage their own programme by choosing which modules to include in the course. College For You approached designers at Italian agency BCPT and asked them, initially, to create an identity that would communicate the difference between this college and other private schools in Italy.

Solution>>College For You was actively involved in the design process of its identity from start to finish, due to its concern about the 'style' of it. Based on 1950s American college football team strips, the bespoke typeface was designed by Italian designers BCPT. Both the colours within the logotype have been applied using metallic tints to help make the logo stand out from other colleges', and the forward slashes at each end are a reference to the mainly web orientated courses that College For You offers students.

What started as a fairly simple corporate identity design commission, developed into a much wider brand strategy project for BCPT. The logotype has been applied onto many communications and also vehicle livery, providing the college with a memorable identity appealing to students and tutors alike.

C4U - College for you s.r.l.
Centro direzionale Quattrotorri
Ellera Umbra - 06100 Perugia
tel. ++39 075 517 1312
fax ++39 075 518 4940
web: www.c4u.it
e-mail: info@c4u.it

C.C.I.A.A. PG 225462
P.Iva 02556480545

Istituto di formazione
modulare per
l'information and
communication
technology

/C4U/
college FOR you

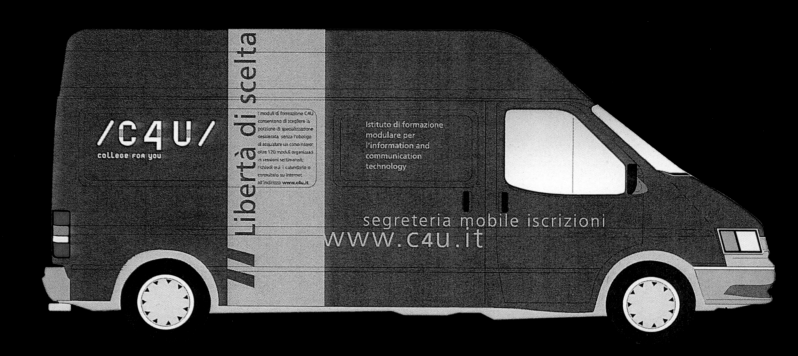

/C4U/
college for you

Istituto di formazione
modulare per
l'information and
communication
technology

C4U - College fro you s.r.l.
Centro direzionale Quattrotorri
Ellera Umbra - 06100 Perugia
tel. ++39 075 517 1312
fax ++39 075 518 4940
web: www.c4u.it
e-mail: info@c4u.it

Istituto di formazione
modulare per
l'information and
communication
technology

Massimo Giornelli
amministratore delegato

C4U - College for you s.r.l.
Centro direzionale Quattrotorri
Ellera Umbra - 06100 Perugia
tel. ++39 075 517 1312
fax ++39 075 518 4940
web: www.c4u.it
e-mail: info@c4u.it

Client>>PRE Consultants Ltd
Design company>>PRE Consultants Ltd, UK

Brief>>The concept, Steaming Sushi, was initiated by UK
consultants PRE as a creative think tank where its designers
could experiment with new ideas. The concept developed
into a website, a device that they wanted to use to promote
their skills and expertise in new media design and technology
to both existing and potential clients. PRE wanted to create
an identity for Steaming Sushi that would reflect its online
work, the name and direction that new media was going in.

try to use the symbols only and ignore explanations

if you fold carelessly, the result will be disastrous

watch out for terms like squash fold

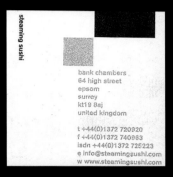

steaming sushi

bank chambers
64 high street
epsom
surrey
kt19 8aj
united kingdom

t +44(0)1372 720920
f +44(0)1372 740963
isdn +44(0)1372 725223
e info@steamingsushi.com
w www.steamingsushi.com

Solution>>The resultant identity is based around the logo, a black and silver symbol created by the designers to ensure that the brand could be recognised by this alone rather than just a name. The logo was also designed to be flexible so that different shapes could be formed and applied to the four variations of the letterhead and business card. The letterhead incorporates origami with each one of the previously mentioned variations featuring a different item to be made: Bat Mask, Water Bomb, G.I Hat and Sampan. Perforations on the lightweight letterhead separate the written and illustrated instructions from the required shape of paper. The identity works across the desired mediums from stationery to website and has won PRE a number of awards including one at the UK's Design Week Awards, 2000.

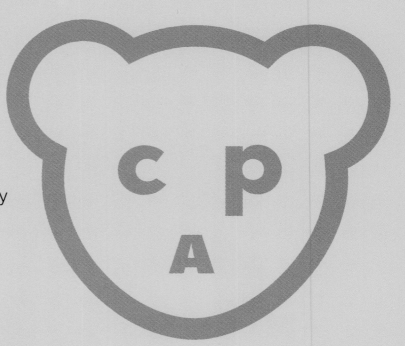

Logotypes Process Interview
Client>>Cerebral Palsy Action
Designers>>Eggers and Diaper, Germany

Brief>>Cerebral Palsy Action was set up and is run by parents, and is currently the only charity in the UK focused on cerebral palsy. It offers a recreation centre for families of disabled children to stay at for weekends, financial grants to help families cope, as well as general support and information for families of sufferers and sufferers themselves. When Berlin-based designers Eggers and Diaper were approached to redesign their identity, the organisation was known as 'cpaction' – cerebral palsy was not openly stated but hidden in the name.

Developing the Identity>>Contrary to the then trend among charities, Eggers and Diaper recommended that a clear statement be made of the disability. This was done for two reasons: firstly because of the organisation's unique focus on the one condition, and secondly because Diaper felt that hiding the name only makes it more difficult or uncomfortable whenever it comes out of hiding. "This in itself was an emotionally charged, but crystallising moment," explained Mark Diaper. "Cerebral Palsy was no longer to be seen as a condition which should be excused or hidden."

A number of different approaches to the identity design explored different issues that Cerebral Palsy Action felt were central to the organisation's identity.

Previously its logo was an illustrated teddy bear surrounded by a circle of type. The bear had been developed into a character called Charlie Bear and real Charlie Bears were given to children as part of its marketing strategy. Initially, Cerebral Palsy Action could not imagine a new identity without the bear, but Diaper felt that the bear only confused and diluted any description of its activity. "However," he explained, "we showed them a possible identity route in which the illustration had evolved into a mark and where the typography functioned pictorially."

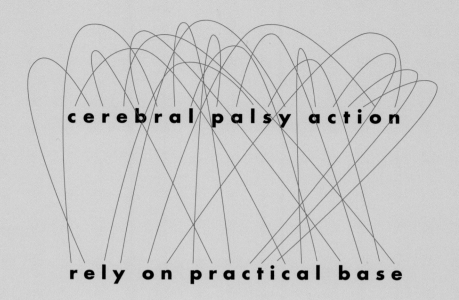

cerebral palsy action

rely on practical base

Another notion that the organisation wanted to reflect pictorially in the identity, was that of its strong sense of teamwork. Again, Diaper felt this was not a suitable approach, given that communicating teamwork would not describe its actual work. But, he did explore this route and while doing so took the opportunity to demonstrate why he believes illustrations rarely make good corporate identities.

Finally, Diaper found a suitable solution. Cerebral Palsy is a term that covers several conditions, all of which are the result of incomplete development of the brain before, during or after birth. "One thought I wanted to concentrate on and turn into an approach was, how do I make sense of this? How can I extract some sense from this condition called cerebral palsy?" he explains. "This is what every parent goes through when their child is diagnosed as a sufferer."

Diaper began by exploring the idea of anagrams to see how far he could go with anagrams of Cerebral Palsy Action. He managed just one complete anagram that made sense, 'rely on practical base'. Diaper used anagram generating programmes but this too had little success.

"In the end I could see that it was possible to extract a whole series of really relevant keywords from their name, so I departed from complete anagrams and ended up in the territory you now see," says Diaper.

c e r e b r a l · · ·
p a l s y · · · · ·
a c t i o n · · · · ·

John King **Operations Manager**

Dalmore House Dalmore Alness Ross-shire IV17 0UY
T 01349 882270 F 01349 882688
E cpa01@globalnet.co.uk W www.cpaction.org.uk

c e r e b r a l · · ·
p a l s y · · · · ·
a c t i o n · · · · ·

c e · **e b r a** · · · ·
· · **l** · · · · · ·
· · · · · · **t i o n**

· · **r e** · · · · · ·
· · · · · · · · · ·
· · · · **a c t** · · ·

c · **r e** · · · · ·
· **a** · · · · · ·
· · · · · · · ·

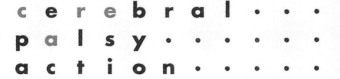

Head Office
Dalmore House
Dalmore, Alness
Ross-shire IV17 0UY
T 01349 882270
F 01349 882688
E cpa01@globalnet.co.uk
W www.cpaction.org.uk

Regional Office
Unit 10,
Willow House
Newhouse Business Park
Grangemouth FK3 8LL
T 01324 474043
F 01324 473769
E cpacentral@care4free.net

Solution>>The final identity sees a large, confident typographic statement of the organisation's name placed within a matrix. By shifting the three words 'cerebral', 'palsy' and 'action' within this matrix the designers were able to highlight a series of words emerging from the name: care, rest, celebration and react. The words chosen reflect the various services and themes that the charity offer or represent. The identity becomes a family of logotypes each with their own specific message.

It also sees a departure from the original colour combination of orange and green. "We defined the choice of colours in opposition to the greens, blues and pastels prevalent in identities dealing with the sphere of health, clinics and children," said Diaper.

sim

simon and lars simon and lars simon and lars

Southgate Studios 2–4 Southgate Road London N1 3JJ
(020) 7684 4814 simonandlars@yahoo.co.uk

Southgate Studios 2–4 Southgate Road London N1 3JJ
(020) 7684 4814 simonandlars@yahoo.co.uk

Southgate Studios 2–4 Southgate Road London N1 3JJ
(020) 7684 4814 simonandlars@yahoo.co.uk

Typography>>

The choice and arrangement of an existing appropriate typeface, or design of a bespoke typeface is a fundamental aspect of identity design. Design concerned with the conveyance of information, the creation of an identity and its application onto business cards, letterheads and compliment slips, is a fundamentally typographic exercise.

At its most basic, the job entails sorting information into hierarchies according to the way in which they will be used. In 'The New Typography', Jan Tshichold said that the aim of typographic layout is communication and that communication must appear in the shortest, simplest, most penetrating form. Some designs follow convention, such as ranging the recipient's address to the left of the letterhead, but many designers today choose to group information differently. Either way the basics hold true; essentially the design must strike a balance between effective communication and a style appropriate to the client.

Not following traditional layout methods, Swiss designers Odermatt and Tissi have created a type-based logo for Swiss art gallery Art Garage (below). In all three applications, the business card, letterhead and envelope, the company name begins on the front of the page and continues on the back.

Designers Simon and Lars have created business cards (above) that see the letter 's' that they both share in their names cropped and used as a device that wraps around the card. On one side is 'simon and lars' with the studio details, on the other the individual name and number. This type of experimentation with the layout allows the reader to interact more fully with the design.

Southgate Stud

on and lars

The design of a typeface is considered by many to be an art form and there are thousands of existing typefaces and font families available for use. However, in some cases none of them fulfil the designer's requirement and so a new typeface will have to be designed. The bespoke typeface has the advantage of making a logo or logotype legally protected. It also makes the design unique and adds a sense of distinction. A bespoke typeface may be felt necessary for many different reasons. For example, in the previous chapter, Italian designers BCPT chose to design a bespoke typeface because, said Marco Tortoioli, designer at BCPT, "no typefaces were right to represent the feeling that we required".

Quentin Newark, principle at Atelier Works, chose to design a bespoke typeface for Box photography studio (page 124) because – as a play on the name – he thought it would be interesting to create a typeface from a series of hand-drawn box shapes. "All logos have some twist that makes them unusual, not just a piece of typesetting, or the fact that they are specially drawn," explains Newark. "This is done for two reasons: firstly it makes the logo legally protected, and secondly it makes it distinctive and unique." He is currently developing a font based on Elvis Presley's body and a typeface in between a serif and a sans serif.

When Jeanne Verdoux, designer at Idle, New York, was commissioned to create a visual identity for French architecture studio Atelier du Pont, she created a typeface based on the font Pop. She manipulated it to emphasise the architectural connotation, with the 'n' of the word 'Pont', meaning bridge, made to look like a bridge. The concept of the layout was to organise the graphic forms on the stationery as an architectural structure, in an attempt to create a typographic space rather than a logotype.

Whether an existing or bespoke typeface is used, the correct and carefully considered specification of its point size, x-height, leading, tracking, line length and alignment, is essential to the readability of text. Each letter can be of a different size if desired, the arrangement of it can be conventional or experimental, and two, three or four typefaces can be used on one letterhead, as long as it is readable and functional.

Southgate Road London N1 3JJ (020) 7684 4814 simonandlars@yahoo.co.uk

Above Left>>Stationery for and by Simon and Lars. **Bottom Left>>** Art Garage stationery designed by Odermatt and Tissi. **Bottom Right>>**Atelier du Pont stationery by New York-based Idle.

Client>>400 Films
Design company>>Frost Design, UK

Brief>>400 Films is a London production company set up in 1999. Vince Frost at Frost design was asked to create an identity for the company that could be used both on print material as well as have the potential to be animated. There was no brief. If anything, Frost was asked to do what he wanted with it.

Solution>>Completed in 1999, the resultant identity sees a strong typographical solution, something Frost Design is well known for. Taking the 400 from the company name, Frost has played around with the numbers to make them the main point of focus on all aspects of the stationery. The numbers were then printed using letterpress to further establish that prominence with Helvetica sitting alongside it as the body text. The green line that features in one way or another on all communications is a symbol of film. It moves with the logo vertically across the different pages, for instance on the letterhead it becomes the margin for the printed letter. The identity was also applied to a poster and animated for use on the company's show reel.

To

Order no

Deliver to

Signature

4 0 0

FourHundred Films Limited

32 Great Pulteney Street London W1R 3DE
Telephone 0171 439 8088 Fax 0171 439 7348
production@four-hundred.com

Client>>Identity
Design company>>SEA Design, UK

Brief>>Identity is a UK-based design and print company.
They approached London's SEA Design in early 2001, with a
view to them creating an identity and stationery system for
this newly founded company. The main requirement was that
the identity that SEA created had to be individual, and stand
out from other printers on the market.

Solution>>Completed in June 2001, SEA Design has
created an identity that makes use of a large, bold typeface
and a non-conventional letterhead and business card layout.
The chosen typeface is Franklin Gothic bold caps, which has
been applied in a number of colours to the stationery system.
The letterhead sees all the company information, including
the name, printed in white on the reverse side of it, while the
information on the business card has been embossed, with
the exception of the company and person's name. This has
been debossed to show a variety of printing techniques over
different applications. Designers have chosen to use colours
that are slightly unusual and colour combinations that would
not normally be seen together.

UNIT 30
ELDON WAY
PADDOCK WOO
TONBRIDGE
KENT
TN12 6BE
TELEPHONE
01892 837989
FACSIMILE
01892 838032
IDENTITY.

UNIT 30
ELDON WAY
PADDOCK WOOD
TONBRIDGE
KENT
TN12 6BE
TELEPHONE
01892 837989
FACSIMILE
01892 838032
IDENTITY.

Client>>Lucy Gibbons, Stylist
Design company>>Fly Productions, UK

Brief>>Lucy Gibbons is a freelance London-based still-life stylist working with a range of clients including Prada, Levi's, Waitrose, Harrods and Elle Decoration. UK designers Fly Productions originally created an identity for her in 2000 but when she moved in 2001, a new identity was requested. The identity had to accommodate the fact that the nature of Lucy's work means that she is always on the go, moving from job to job, but needs to be able to be contacted at all times.

Solution>>Sophia Wood, designer at Fly Productions, has played on Lucy's need to be contacted by printing her mobile telephone number in large Univers typeface on all communications in two shades of pink. The typographic layout is unusual but perfectly suited to appeal both to Lucy and her clients and is a great way to get the importance of her mobile number across. It was Wood's intention that Lucy should type letters to clients directly over the pink printed type on the letterhead rather than the reverse blank side. The positions of the type on the stationery sees a mixture of range left and range right layout with printing carried out using only one colour due to budget restrictions.

LUCY GIBBONS stylist

07768

005763

120 ALBERTA STREET
KENNINGTON LONDON
SE17 3RT
020 7735 3454

LUCY GIBBONS stylist

07768
005
763

120 ALBERTA STREET
KENNINGTON LONDON
SE17 3RT
020 7735 3454

LUCY GIBBONS stylist
07768
005
763

120 ALBERTA STREET KENNINGTON LONDON SE17 3RT 020 7735 3454

120 ALBERTA STREET
KENNINGTON LONDON
SE17 3RT
020
7735
3454

Client>>desq
Design company>>Peter and Paul, UK

Brief>>UK company desq, founded in 1998, create innovative digital educational programmes for clients such as BBC Online, Channel 4 television and Learndirect. Although predominantly working within web and multimedia, the platforms and projects undertaken are extremely diverse, and audiences range from children to adults returning to learning. The only definable continuity is that each project blends entertainment and education, or 'Edutainment' which has become desq's philosophy. Designers Peter and Paul were asked to re-brand desq to better reflect the attitudes and ideas of the company and their area of work.

Solution>>The solution was to create a hand-drawn logotype using circles, squares, hexagons and stars to create the letters. "When we are young, we appropriate simple shapes and forms," explains designer Paul Reardon. "Triangles, circles and squares become almost instantly recognisable. As this is the basic foundation of learning it seemed fitting to build a typographic mark from these shapes." The mark can be redrawn in different mediums and using different objects that conform to those four shapes. The wordsearch, a game designed to challenge intellect and be entertaining, became the basic idea for the stationery. The letterheads, compliment slips and business cards are generic, simply by ringing one of the hidden words the letter can become an invoice, or a memo and the business card becomes specific to an employee.

desq: // the workstation 15 paternoster row
sheffield s1 2bx. uk. t:+44 (0)114 221 0205
myname@desq.co.uk / www.desq.co.uk

desq: // the workstation 15 paternoster row
sheffield s1 2bx. uk. t:+44 (0)114 221 0205
info@desq.co.uk / www.desq.co.uk

Client>>Archives Nationales Audiovisuelles du Travail et des Entreprises Au Creusot (ANATEC)
Design company>>Trafik, France

Brief>>ANATEC is an institution that collects and archives films and presentations made by businesses for both internal and external communication. Once collected, they compile the films to make a history of a particular business, for example the history of Kodak. There was no brief as such so designers at Lyon-based design agency Trafik created the company's identity on instinct.

Solution>>"We wanted to be evocative but not illustrative," explained Damien Gautier at Trafik, "not make a logo but a graphic system." The result is a strong typographical solution using a sequence of lines to represent film, time and archiving. Giving it an edge and further adding to the film reference are one or two slightly blurred lines giving a sense of movement to the identity. Sitting alongside the vertical lines is each letter of the company's acronym with the full name written out below. Despite the fact that in France it is widely thought that blue is 'the' institutional colour, Gautier chose to use green for both the type and logo. Complimenting this the colour features full bleed on the reverse of the letterhead, save for the narrower sequence of white lines towards the bottom. Tarzanna and other Zuzana Licko typefaces have been used throughout.

A N A T E C

Archives nationales du travail au Creusot
audiovisuelles et des entreprises

11, rue Jules Guesde Tél. 33 (0)3 85 55 85 25 Siret 424 392 876 00019
BP 121 Fax 33 (0)3 85 55 86 93 Code APE 925A
71203 Le Creusot cedex anatec.creusot@wanadoo.fr

Typography Process Interview
Client>>The Women's Library
Design company>>Atelier Works, UK

Brief>>Part of London Guildhall University, The Women's Library is a new centre for international study that had its opening exhibition in January 2002. It is located in a converted wash house and includes a reading room – containing the Fawcett collection of Women's history – an exhibition space and a café. London-based designers Atelier Works were asked to create an identity which allowed the library to operate both as an academic resource and as a destination for exhibitions and events or just a cup of coffee. The identity had to be used to attract a worldwide readership of both students and academics.

Developing the Identity>>Designers from Atelier Works met with the whole of the client team, including the building's architects, to try and establish how the fresh ambitions of the director, Antonia Byatt, might be expressed through the identity. Libraries, and librarians, have a somewhat sombre reputation and so the designers' initial concerns were about explaining what was on offer clearly, particularly since this was not a typical library. By a process of consultation and rationalisation and looking at the names of other comparable organisations, designers removed the word national and reduced the name to 'The Women's Library' and explained its activities as 'celebrating and recording women's lives'. "The visual expression of the name could then begin," explained John Powner, one of the principles at Atelier Works. "We explored a number of options using libraries and books, shelves etc., but none of them really showed a different kind of library. The strongest and most memorable idea seemed to be that of 'borrowing' a letter from the shelf," he added. "A little irreverent and very unexpected, perfect." The client was fairly involved in the design process from start to finish. Powner saw that it was very important for both Atelier and the success of the new identity that the client was closely involved in the process as it is the client who will use the identity and promote it to the public. The client felt stongly that the colours used for the identity should be striking as well as a little feminine. With such a strong basic idea of borrowing, Powner felt that there was plenty of scope for colour choice.

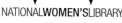
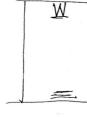
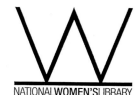
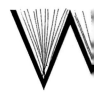

PILES OF BOOKS

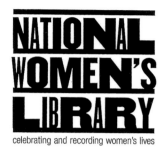

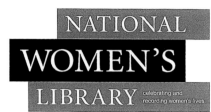

NATIONAL
WOMEN'S
LIBRARY
celebrating and
recording women's lives

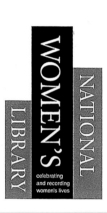

LIBRARY SHELF

NATIONAL**WOMEN'S**LIBRARY
celebrating and recording women's lives

NATIONAL
WOMEN'S
LIBRARY
celebrating and recording women's lives

NATIONAL
WOMEN'S
LIBRARY
celebrating and recording women's lives

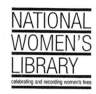

THE
WOMEN'S
LIBRARY
celebrating and recording women's lives

THEWOMEN'SLIBRARY
celebrating and recording women's lives

THE**WOMEN'S**LIBRARY

NATIONAL
WOMEN'S
LIBRARY
celebrating and recording women's lives

THEWOMEN'SLIBRARY

NATIONAL
WOMEN'S
LIBRARY
celebrating and recording women's lives

THE WOMEN'S L BRARY

celebrating and recording women's lives

THE WOMEN'S LIBR RY

celebrating and recording women's lives

THE WO EN'S LIB

celebrating a

I have not been able to answer, despite my thirty years of research into the feminine soul, 'What does a woman want?' *Sigmund Freud, 1920*

A re you aware hat you are, perhaps, he most discussed nimal in the universe? *Virginia Woolf, 1929*

Christine Wise BA DipLib ALA
Librarian

The Women's Library
Calcutta House
Old Castle Street
London E1 7NT
t +44 (0)20 7320 1180
f +44 (0)20 7320 1177
e wise@lgu.ac.uk
www.lgu.ac.uk/fawcett

Are you aware that you are, perhaps, the most discussed animal in the universe?
Virginia Woolf, 1929

Solution>>A strong pink complimented by a green/blue underline and bodytext colour was felt appropriate for the final design. Powner chose to use Champion Gothic typeface as it is a condensed, bold headline font which has uniform but interesting characters. Using the letters close together like a library shelf allowed Powner to set the type in a large and dramatic way and then 'borrow' different letters from the letterhead. Joanna Italic supports the headline in an elegant and feminine line underneath.

"The visual pun of 'borrowing' a letter from the name was exactly what we were looking for to make readers look twice and think 'why is there a letter missing?'," explained Powner. "Finding it at the bottom of the page leads you to a more thought-provoking set of quotes about women's roles and attitudes, all chosen by the client."

These memorable quotations about women's history are from such figures as Sigmund Freud, Elizabeth Barrett Browning and Virginia Woolf. One from Virginia Woolf, 1929, reads, "Are you aware that you are, perhaps, the most discussed animal in the universe?" using the borrowed 'A' to begin it. Similarly, using a borrowed 'I', a quotation from Sigmund Freud, 1920, reads, "I have not been able to answer, despite my thirty years of research into the feminine soul, 'What does a woman want?'"

Two versions of the final logo were drawn to accommodate smaller sizes, different formats and a range of applications including building signage. Powner had ensured that the simplicity of the design allowed for this flexibility.

Colour and Texture>>

Colour is one of the most important aspects of an identity design and will probably be the most discussed matter between the designer and client. A cause for contention, colours have great impact, meaning and presence, and choosing a corporate colour is a long lasting decision not to be taken lightly.

Of course corporate colours are often already in existence, or if not, then the client can have very specific ideas about what he or she wants for the company, but it is the audience that the company is appealing to that matters. Different colours appeal to different people and can have different connotations or evoke different emotions and associations in the reader.

Colours therefore become categorised, feminine or masculine, tasteful or not, classic or fashionable, organic or technological, traditional or contemporary and so on. They can have different meanings: in China red is seen as a sign of luck; in the UK, the combination of red, white and blue can be seen as being patriotic; while in France, it is generally assumed that blue is the corporate colour for institutions (see Trafik's design for ANATEC on page 72).

Red is a dramatic colour and is generally accepted by both sophisticated and unsophisticated demographics. Blue is generally considered a more reserved and conservative colour, while orange and brown tend to have more organic, earthy properties. Green is generally associated with environment or nature, and gold and silver with wealth. The use of simple black and white can look quite clinical but is favoured for its simplicity and understated classic values. Of course, this type of list could be seen as being very personal, but these generalised reactions and feelings towards colour are based on a certain amount of sound research.

Banks tend to opt for more 'serious' colours for corporate systems like greys, blues and generally darker colours, whereas companies aimed at a younger demographic are likely to be more experimental with colour and colour combination. Some companies are synonymous with certain colours like the red and yellow of the Shell garage, the blue and red of British Telecom or the red of Coca-Cola.

But whatever the situation, whoever the client and the intended audience, colour choice should be based purely on the stated objectives of the project. If you deviate from this, the decision will become far more difficult and open to suggestion and debate.

Above Left>>Rosemary Butcher stationery by Why Not Associates. **Bottom Left>>**Sheppard Robson stationery designed by ATTIK, UK. **Right>>**Yosho stationery by SEGURA INC, USA.

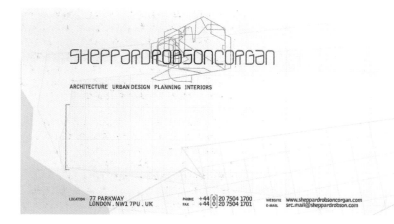

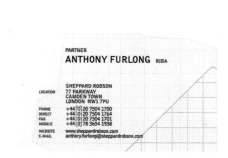

Texture on stationery can be created either by physically manipulating the paper through embossing, stamping or applying foil, or by the use of pattern and imagery. As shown here, international design agency ATTIK incorporated a blueprint grid into the original illustrations for UK- and US-based architecture firm Sheppard Robson.

The use of a grid as a background image in a variety of colours or positions, darkness or lightness adds both texture and depth to the identity featuring on all of Sheppard Robson's communications. Similarly, US designers SEGURA INC have used a series of brightly coloured stripes in an identity for client Yosho.

UK-based designers HGV have used a combination of imagery and manipulation to produce a very textured letterhead for luxury pet shop client Pet (see pages 84–85). Similarly, designers at Johnson Banks have embossed a design on the whole sheet of letterhead paper, which to the touch feels like a piece of material (see page 122 onwards for further examples of surface effects).

London-based Why Not Associates have used strong textural imagery on the reverse side of a letterhead designed for contemporary dancer Rosemary Butcher. Abstract photographs of metal textures have been manipulated in Photoshop and printed on a solid silver background with the black halftone image overprinting that. The idea is that once the letterhead is folded, it is surrounded by the metallic texture.

Client>>West Yorkshire Playhouses Creative Networking and Directors Club
Designer>>Thompson Design, UK

Brief>>The West Yorkshire Playhouse is a theatre based in Leeds, UK. A large number of its productions are of national significance and often, after premiering in Leeds, tour the country and finish up in London. Following Thompson Design's re-vamp of the theatre identity in summer 2001, it was decided that a re-launch of The Business Circle, the theatre's corporate hospitality operation, was also needed.

Solution>>Designer Ian Thompson did not want to create another logo to compete with the Playhouse's own logo (set in the top left corner of all Business Circle's stationery). Instead he changed the Business Circle's name to The Directors Club and added the strapline 'Creative Networking'. This strapline proved so popular that it became the new name of the theatre's Corporate Affairs department. The added graphic grid set on all stationery is intended to represent the concept of creative networking in a theatrical and up-market way. "We thought that a fractal-based mor-

WY PLAY HOUSE

CREATIVE
NETWORKING

WEST YORKSHIRE
PLAYHOUSE
PLAYHOUSE SQUARE
QUARRY HILL
LEEDS, LS2 7UP
TEL: 0113 213 7800
FAX: 0113 213 7250
www.wyp.org.uk

LEEDS THEATRE TRUST LTD.
REGISTERED IN ENGLAND
REGISTERED CHARITY No.255460
VAT No. 545 4860 17

WY PLAY HOUSE

CREATIVE
NETWORKING

WITH COMPLIMENTS

WEST YORKSHIRE
PLAYHOUSE
PLAYHOUSE SQUARE
QUARRY HILL
LEEDS, LS2 7UP
TEL: 0113 213 7800
FAX: 0113 213 7250
networking@wyp.org.uk
www.wyp.org.uk

Client>>The Building
Design company>>Peter Heykamp, Holland

Brief>>The Building is a communication advice agency based in Amsterdam. In 1999, they asked Dutch designer Peter Heykamp to create them a visual identity. The company uses four disciplines when working with clients: philosophy, strategy, creativity and energy. The brief to Dutch designer Peter Heykamp was completely open.

Solution>>Using the already established company name and its four disciplines as a starting point, Heykamp decided to integrate technical line drawings of floor plans of graphically interesting and internationally well-known buildings in the identity. His aim was to connect the practical meaning of a building to the more philosophical meaning of The Building's four disciplines. For philosophy, Heykamp has used the image of an ancient Greek theatre set in turquoise. For strategy, set in light blue is an image of The Pentagon in Washington. Creativity has been represented by an image of the Java Bridge, Amsterdam set in light grey, and finally, energy has been visualised by The Atomium, Brussels, set in vibrant red.

Heykamp has used transparent stock Neenah Columns to enable the viewer to see the images from both the front and back of the stationery. The colours have been printed to the reverse of the paper, which also adds to the effect. The logotype has been created using Humanist 521 BT with body type in Letter Gothic Pitch BT-Roman.

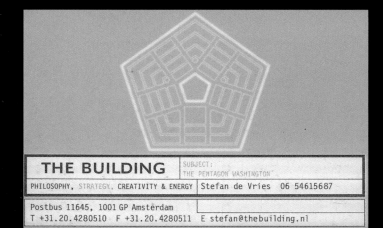

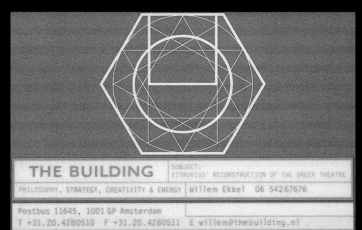

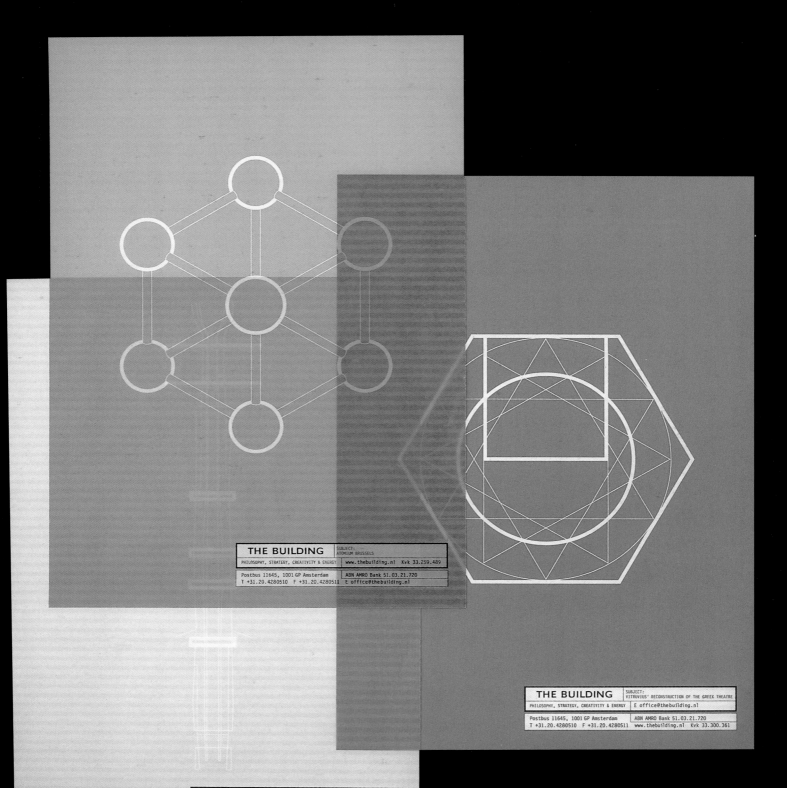

THE BUILDING
SUBJECT:
ATOMIUM BRUSSELS

PHILOSOPHY, STRATEGY, CREATIVITY & ENERGY | www.thebuilding.nl Kvk 33.259.489

Postbus 11645, 1001 GP Amsterdam | ABN AMRO Bank 51.03.21.720
T +31.20.4280510 F +31.20.4280511 | E office@thebuilding.nl

THE BUILDING
SUBJECT:
VITRUVIUS' RECONSTRUCTION OF THE GREEK THEATRE

PHILOSOPHY, STRATEGY, CREATIVITY & ENERGY | E office@thebuilding.nl

Postbus 11645, 1001 GP Amsterdam | ABN AMRO Bank 51.03.21.720
T +31.20.4280510 F +31.20.4280511 | www.thebuilding.nl Kvk 33.300.361

THE BUILDING
SUBJECT:
"DE JAKABRUG" AMSTERDAM

PHILOSOPHY, STRATEGY, CREATIVITY & ENERGY | www.thebuilding.nl Kvk 33.259.489

Postbus 11645, 1001 GP Amsterdam | ABN AMRO Bank 51.03.21.720
T +31.20.4280510 F +31.20.4280511 | E office@thebuilding.nl

Client>>Pet
Designer>>HGV Design, UK

Brief>>HGV Design, London, were approached by Pet in summer 2001 to create an identity for its newly opened luxury pet gift store in London. Pet is aimed at wealthy and celebrity pet owners who are, as HGV creative director Pierre Vermeir said, "keen to smooch their pooch". Consequently, the client required an identity that would tap into their potential customers' passion for pets and emulate the luxury products and service it offers.

Solution>>HGV's solution was to create a dog tag-like logo, which has been hand drawn and appropriately foil blocked in silver onto the stationery. On the reverse, the use of strong imagery, by way of photographed cat and dog fur, adds to the rich and luxurious feel that the identity aims to achieve. Its application onto the shop signage, livery, interior decoration, stationery and gift-wrap, enhance the Pet pampering experience for what the strapline describes as 'the modern metropolitan pet' and its owner. This clever, witty identity has been nominated for several awards including The Art Directors Club, USA, Design and Art Direction Awards, UK and the Design Week Awards, UK.

Russell Ha

for the mo
metropolita
veterinary o

351 archway
highgate
london N6 5AA

T 020 8341 48
F 020 8340 82
E mail@high

Client>>Rupert Sanderson
Design company>>Johnson Banks, UK

Brief>>Rupert Sanderson is a shoe designer living and working in London. He needed a simple identity for his business that would be both appropriate and relevant to his clients and represent his style of design. He also wanted the identity to communicate the craft skills of a shoe designer in a way that stood out from other fashion communication. Sanderson had specific views about colour, which were adhered to by the designers.

Solution>>The solution that Michael Johnson of Johnson Banks came up with, was a hand drawn logotype inspired by a shop front in Swiss Cottage, North London. A lot of time was spent developing the typeface in such a way that it looked charmingly hand crafted, reflecting Sanderson's design practice of using old fashioned cobbling skills. The logotype was then reverse blind embossed onto the letterhead and business card, as Johnson felt that it was important that the name could be read properly on the reverse of communication material as well as on the front. In addition to this, the stock, which to the touch almost feels like woven material, was embossed with a texture after the logotype was embossed. Together the hand drawn logotype, embossing and textured paper make for a distinctive set of stationery that immediately gives the impression of a company that has a certain quality.

Rupert Sanderson Shoes Limited

The Last House
12 Shrewsbury Road
London W2 5PR

t 0044 (0)870 750 9181
f 0044 (0)870 750 9182
e info@rupertsanderson.co.uk

Rupert Sanderson Shoes Limited
The Last House
12 Shrewsbury Road
London W2 5PR

t 0044 (0)870 750 9181
f 0044 (0)870 750 9182
e· info@rupertsanderson.co.uk

Client>>NSL Architects
Design company>>R2 Design, Portugal

Brief>>Founded in 1999, NSL Architects is named after its owner Nicolau de Sousa Lima. After a year in business, NSL was becoming quite established and felt it was time that an identity and personality was created for them. They approached Portugal-based R2 Design to create a sober, timeless and minimal identity that would overcome present trends. NSL also wanted an identity that would visually and texturally represent the company that currently holds a very professional, dynamic and active position in the Portuguese architecture market.

Solution>>Completed in late 2000, designers at R2 Design approached the commission with the idea of creating interesting features that could be found in the identity. They also wanted to make graphic reference to volume, space and light within the identity design as they are all important elements of the environments that the NSL Architects work with, or in. This has been achieved by using reflective silver metallic ink on the address sticker, different shades of grey on the front and back of the business card, envelope and letterhead, and the blind embossing technique applied to the logo, which has been used as an obvious and instantaneous reference to volume. Proforma and Trade Gothic typefaces have been used throughout on a matt stock.

Nicolau de Sousa Lima · Arquitectos, lda
Rua Professor Augusto Nobre, 451 G
4150 119 Porto · Portugal

NSL **ARQUITECTOS**

T +351 22 616 06 95
F +351 22 616 06 95
E nslarquitectos@clix.pt

NSL

ARQUITECTOS

Nicolau de Sousa Lima · Arquitectos, lda
Rua Professor Augusto Nobre, 451
Sala G · 4150 119 Porto · Portugal

nslarquitectos@clix.pt

NSL

ARQUITECTOS

Nicolau de Sousa Lima · Arquitectos, lda
Rua Professor Augusto Nobre, 451 G
4150 119 Porto · Portugal

T +351 22 616 06 95
F +351 22 616 06 95
M 93 616 06 95
E nslarquitectos@clix.pt

Nicolau de Sousa Lima
Arquitecto

NSL

ARQUITECTOS

Rua Professor Augusto Nobre, 451 G
4150 119 Porto · Portugal

T +351 22 616 06 95
F +351 22 616 06 95
E nslarquitectos@clix.pt

Colour and Texture Process Interview
Client>>Glasgow School of Art
Design company>>MetaDesign, Germany

 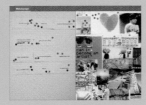 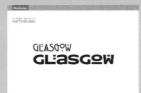 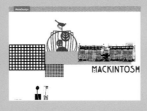 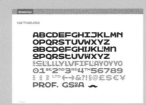

 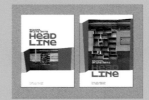

Brief>>The Glasgow School of Art (GSA) is one of the few independent colleges of art in Great Britain. Founded in 1845, it rapidly became a centre of art, architecture and design. At the heart of the campus, is the superb building designed by Charles Rennie Mackintosh, who studied and taught at the GSA and had a considerable influence on its creative culture. In 2001, the GSA asked Berlin-based MetaDesign to revamp its corporate identity in an attempt to attract a new generation of students and move the school into a new era.

Developing the Identity>>Previously, the school did not have a corporate identity as such, although the Mackintosh typeface was omnipresent and very much associated with the school. However, not only was it no longer suitable for all the departments, it was no longer unique to the school. The style had been imitated and used by many businesses all over the country and become known as the 'Mockintosh' style.

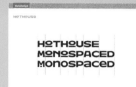

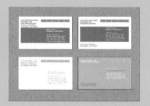

Firstly, designers at Meta prepared a workshop in Glasgow with representatives of all the academic and trading brands of the school to find out what they thought about the development of a new identity and what ideas they had. This resulted in a final mood board and a list of core values that once back in Berlin were used to develop several design directions.

Designers Daniel Thoma and Jürgen Huber were faced with a few problems during the development. There were questions about how much the original Mackintosh design should be quoted, and they also wanted the design to be both playful and serious. Most importantly though, it was essential that the identity act as an umbrella for all the School's activities which include the three academic brands – The School of Design and Craft, The School of Fine Art and The Mackintosh School of Architecture; and the three trading brands – The Digital Design Studio, The Centre for Advanced Textiles and Glasgow School of Art Enterprises.

The designers processed a lot of information about the school provided by the GSA and looked at the results of the workshop, in order to come up with four to five design approaches during the early stages of development. It became clear very early on that creating a corporate font would, on the one hand, help transfer the Mackintosh heritage into the present day whilst on the other, create a strong and easy-to-handle corporate design tool. After intense discussions, two solutions were presented to the client, a decision was made almost immediately and no changes were necessary.

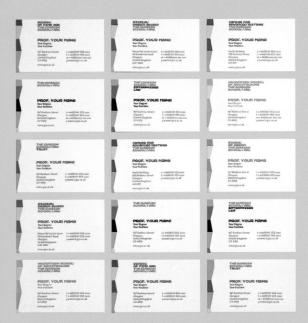

Solution>>The chosen identity sees the various schools and departments united under a common visual identity with a strong logo using the bespoke typeface, Hothouse. Hothouse has been developed in a way that allows for it to be used flexibly as a headline font on all media and draws on stylistic elements employed by Charles Rennie Mackintosh.

Thoma and Huber have also created a colour environment with various compositional possibilities for the school. Development of a colour scheme was based on the Mackintosh building where designers found what they called the "building brown". Each department has received its own colour, and the different combination possibilities ensure a high degree of recognition for the college as a whole.

"Every brand uses the 'building brown' plus its own specific brand colour," explain Thoma and Huber. "So every school has its own identity but still comes under the umbrella of The Glasgow School of Art. The overall approach to finding the brand colours was to represent the GSA as a creative hothouse so the chosen colours are fairly bright rather than dark."

A sequence of the School colours arranged in a bar with a jagged edge appears as a graphic element in all mediums, in an attempt both to support the wider branding project and emphasise the creative focus of the college.

THE GLA
SCHOOL

DIGITAL
DESIGN STUDIO
THE GLASGOW
SCHOOL OF ART

SCHOOL
OF DESIGN
THE GLASGOW
SCHOOL OF ART

THE GLASGOW
SCHOOL OF ART
TRUST

THE GLASGOW
SCHOOL OF ART
ENTERPRISES
LTD

MACKINTOSH SCHOOL
OF ARCHITECTURE
THE GLASGOW
SCHOOL OF ART

SCHOOL
OF FINE ART
THE GLASGOW
SCHOOL OF ART

ntre FOR
vanced Textiles
E GLASGOW
HOOL OF ART

OW
RT

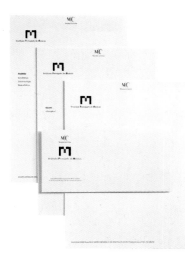

Grids and Guides>>

When Paul Rand completed the IBM logo in 1956 he also created one of the first identity manuals to accompany it – a set of guidelines that instruct the client on the correct application of the identity across all possible mediums. It not only included the design of the logo, but also the size, colour and way in which it was to be applied correctly in particular situations. Today, these style manuals have become increasingly common and are viewed as essential to most major identity projects. They avoid the misuse of an identity, such as use of non-approved colours or images, as well as inform the user of the correct way to lay out a letter, facsimile or invoice.

The manual should describe the identity's correct application by both statement and example. The letterhead section of an identity manual, for example, should tell the user where on the sheet to put the recipient's address, how far down the sheet to start typing, how far in from the left-hand side, and where to stop on the right. These instructions should be accompanied by an image of a laid-out letter. In some cases, it may contain stylistic recommendations such as whether to use numerals or words for numbers, how to write dates and percentages, or even how to sign a letter.

Today, many identity manuals include a digital file with master artwork that can be reproduced internally and distributed. It ensures that once the designer's job has been done, any further reproduction – whether relating to advertising, vehicle liveries or a website – will be applied correctly without the help of the designer.

The modern use of grids is thought to have originated with Bayer at the Bauhaus, and became synonymous with the ordered Swiss style design of the 1940s and 1950s. Using a grid and making guidelines is an essential part of creating visual consistency and the stationery package is an excellent example of how one initial decision can inform the following decisions to ensure a consistent and logical identity system.

Above and Below>>Stationery and style guide for the Institute of Portuguese Museums designed by Joao Machado Design.
Right>>Make letterhead with dummy text by CHK Design.

the organisation for women in the arts

мαке

Institute of Contemporary Arts
Marketing Department
12 Carlton House Terrace
London SW1Y 5AH

107–109 Charing Cross Road
London WC2H 0DU
T 44 (0)20 7514 8860
F 44 (0)20 7514 8864
E make@csm.linst.ac.uk
Registered Charity Number: 295 968

London, 20. March 2002

Dear Alex,
Axcludat iurgia finis. Best vetus atque probus, centum qui perficit annos. Cuid, qui deperit minor uno mense vel anno, inter quos referendus erit. Deteresne poetas, an quos et praesens et postera et aetas. Este quidem veteres inter ponetur honeste, qui vel mense brevi velum toto est iunior anno. Factor permisso, caudaeque pilos equinae paulatim vello unum, demo etiam unum, cadat elusus ratione ruentis acervi, qui redit in fastos virtutem aestimat annis miraturque nihil nisi quod Gibitina sacravit. Poetas an quos et praesens et postera et aetas. Este quidem veteres inter ponetur honeste, qui vel mense brevi velum toto est iunior anno. Factor permisso, caudaeque pilos ut equinae paulatim vello unum, demo etiam unum,

I look forward to hearing from you soon

With kind regards

Catherine Grant
Distribution & Subscriptions

Central Saint Martins
College of Art and Design
THE LONDON INSTITUTE

Invisible, except to the trained eye, grids are the foundation of ordered and consistent design. However, a stationery package can not rely on a well designed grid alone. To be successful, consistent decisions should be made about colour, typography and layout across the package, ensuring that the design is coherent and each item relates to the other.

Christian Kusters at CHK Design has based the layout and design of contemporary woman's art organisation and magazine 'make' around how the letterhead will be folded. The concept of the design is that it is based on a woman's perspective of art as opposed to a man's, therefore Kusters chose a simple visual metaphor and replaced the 'm' in 'make' – men – with an upside down 'w' – women.

Kusters used two blue lines to indicate the left and right borders and tinted areas, to show where the address and main text should sit. The logo is centred and offset by adding the by-line. To retain a grid-like feel Kusters has diagonally aligned the sender's address with the by-line. Helvetica is the text font chosen in order to contrast with the Times logo.

There are no rules for the layout design of a stationery set, but a set of precedents and nationally recognised standards means that most business cards, letterheads and compliment slips are of a similar shape and size. While designers are free to disregard national standards, they should only do so after some thought.

Paper is now produced in standard sizes, and deviating from that may create the need for a more expensive bespoke sheet. This did not prevent Dutch designers KesselsKramer from deviating when they created an identity for 4ft-tall UK actor Little Pete (see page 149). The letterhead is 181 x 128mm, the business card is 49 x 30mm and the envelope 132 x 67mm. This, above all, was an obvious play on his height and even though a little more expensive quite possibly worth it to draw that little bit more attention to him – essential for an actor.

Guia de Identidade Visual

MC

o Portugues de Museus

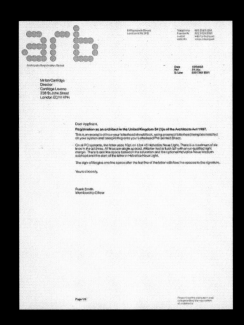

Client>>Architects Registration Board (ARB)
Design company>>Cartlidge Levene, UK

Brief>>ARB was set up in 1997 to replace the Architects Registration Council of the UK. Its task was twofold: to represent consumers' interests, as well as act as a registration body for the architectural profession. ARB wanted a new identity that would better reflect its recent internal changes and see a move away from its previous, rather outdated, identity. Cartlidge Levene was appointed to create a corporate identity in late 1998.

Solution>>The designers have created a new dot logotype that is constructed from an interlocking circular grid built using Quark. This is accompanied by an endorsing strap line spelling out each work in Helvetica. The identity represents the unification of purpose and standards that the ARB brings to the architectural industry and can be used in various ways to create a graphic language.

The sober keyline grid is used for information leaflets and stationery whilst a more playful circular photographic dot screen is used for colourful images in the annual report. This flexibility allows appropriate graphic expression across the range of materials that ARB produce.

Designers chose yellow and grey as the corporate colours and they have been applied to ARB communications accordingly. The logotype is printed in grey on all official correspondence while the yellow is played up for press releases and consumer literature.

8 Weymouth Street
London W1N 3FB

Telephone 020 7580 5861
Facsimile 020 7436 5269
e-mail info@arb.org.uk
website www.arb.org.uk

Architects Registration Board

8 Weymouth Street
London W1N 3FB

Architects Registration Board

With Compliments

Protecting the consumer and
safeguarding the reputation
of architects

Bachelor of Architecture
July 1973

School of Architecture
and Building Engineering
University of Bath

Client>>Ariane's Cup 2002
Design company>>Eggers and Diaper, Germany

Brief>>The Ariane's Cup 2002 is a week-long series of events featuring a sailing regatta, a space exhibition, various evening functions and seminars in Schleswig-Holstein, northern Germany. It is organised for the international space community and aims to bring together the rather disparate Ariane 'family' for a week of professional exchange and socialising. German design agency Eggers and Diaper were asked to design the corporate identity of this event, with a view to applying the identity onto the broader context of The European Space Agency in general.

Solution>>Mark Diaper has created an identity that is reminiscent of space technology in general. A typeface and logo were developed based on a visit to the European Space Agency's Bremen plant. The use of circles and rounded corners was noticeable in much of the engineering design being applied in the International Space Station 'Columbus', as right angles have an inherent structural weakness. Designers used this shape grammar as a starting point for the typeface. Dream-like imagery has been applied to the reverse of the letterhead, compliment slip and business card in contrast to the technology-driven style of the design and layout. The letterhead has to be folded in a particular way so as to allow the subject of the letter to be visible before it is unfolded. The overview system (that features at the top of the letterhead) continues on the compliment slip and business card which has a space for hand-written text.

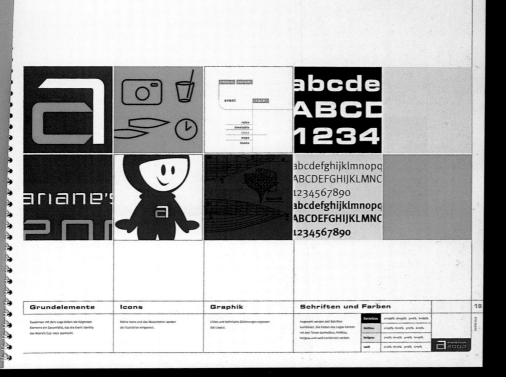

Grundelemente	Icons	Graphik	Schriften und Farben		18
Zusammen mit dem Logo bilden die folgenden Elemente ein Gesamtbild, das die Event Identity des Ariane's Cup 2002 ausmacht.	Kleine Icons und das Maskottchen werden als Illustration eingesetzt.	Linien und technische Zeichnungen ergänzen das Layout.	Insgesamt werden drei Schriften kombiniert. Die Farben des Logos können mit den Tönen dunkelblau, hellblau, hellgrau und weiss kombiniert werden.		

Client>>Broadcast Centre Netherlands
Designer>>Mattmo, Holland

Brief>>The Broadcast Centre Netherlands is the facilities arm of the Holland Media Group dealing with production, post-production and broadcasting of the network's programmes. BCN employs a large number of staff who work across all areas of television production. It asked Mattmo Design, Holland, to produce an identity that would bring all those people together and give them a sense of belonging to a specific company. It also wanted some element of the identity to show the individual skills they use to work together as a team.

Solution>>Mattmo's solution was to create a strong black and white logotype using Berthold Akzidenz Grotesk Condensed to represent the company as a whole. A series of different abstract images, created by using close-up stills of filmed BCN programmes, including talk shows and quizzes, have been applied full bleed to the back of the business cards to give the required sense of individuality as well.

Mattmo felt that the combination of these two design elements brought the company together as a whole but also recognised and highlighted the specialities of different departments and employees. The layout combines the technical, innovative and socially sympathetic. Because of its neutrality and simplicity, the BCN logotype can be applied to the required wide range of communication formats and a style guide was produced to enable BCN to apply the identity consistently.

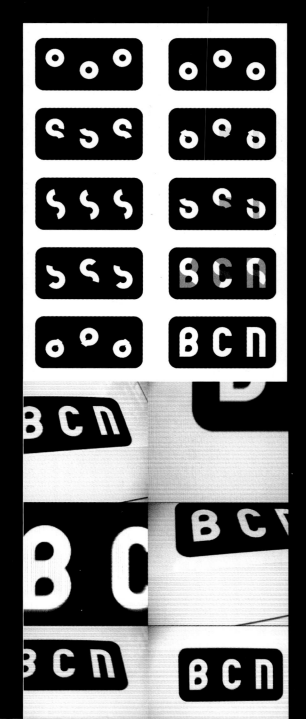

BCN

broadcasting center nederland b.v.

Franciscusweg 341 | Postbus 22400 1202 CH | Hilversum | T. 035 6785200 F. 035 6785250

Kvk Gooi- en Eemland 32082804

AAN

FACTUUR

FACTUURNUMMER

DATUM UW REFERENTIE KLANTNUMMER

OMSCHRIJVING	BEDRAG IN EURO'S

ONS BTW-NR: NL 809.380.080 B01

SUBTOTAAL

BTW BEDRAG

TOTAAL

Wij verzoeken u het totaalbedrag binnen 30 dagen na factuurdatum over te maken op ons
bankrekeningnummer 58.58.58.135 t.n.v. BCN te Hilversum, o.v.v. factuur- en klantnummer.

BCN

broadcasting center nederland b.v.

Franciscusweg 341 | Postbus 22400 1202 CH | Hilversum | T. 035 6785200 F. 035 6785250

Kvk Gooi- en Eemland 32082804

AAN

DATUM BETREFT

BCN

broadcasting center nederland b.v.

Franciscusweg 341 | Postbus 22400 1202 CH | Hilversum | T. 035 6785200 F. 035 678525

I AM

Client>>Isabelle Alexander Marketing
Design company>>Atelier Works, UK

Brief>>Isabelle Alexander Marketing was set up in 2001. It needed an identity and so approached London-based designers Atelier Works who were simply asked to create an identity that incorporated the company name. It was limited in the first instance to core stationery requirements only.

Solution>>As Isabelle Alexander Marketing is a fairly lengthy title designers felt it was necessary to seek ways to shorten the wording during the early design stages. The resulting acronym is the most fortunate result of reducing the name to its barest minimum, IAM. It is an acronym loaded with design possibilities. Designer Ian Chilvers saw it as the start of something, I am ... what?

This line of thinking led them to a typographic solution rather than to a more conventional graphic mark for an identity. The identity has then been adapted to the different communications by starting with I AM and ending with sentences such as 'writing to you', or 'invoicing you'.

The colours used are clean and modern and to compliment this the designers chose to use DIN, a very clear typeface that was designed for the German transport sign system. It provides a complete contrast with both traditional serif and modern sans serif typefaces and is also an investment for possible future applications.

A template grid was integral to the design solution and the client was provided with a PC template. The litho-printed acronym started a sentence that was completed with the digitally printed letter. These two elements could only align themselves properly if each new sentence was overwritten as part of the letter template.

I AM sending you this with compliments

Isabelle Alexander Marketing
A 23 Strathmore Road London SW19 8DB
T +44 (0) 20 8944 6209 **F** +44 (0) 20 8944 6148
E isabelle@IAMonthenet.co.uk

I AM invoicing you

A.N. Other
15 Some Road
Some Town
Some City
SE 14 9NJ

02.01.01

Dear A.N. Other

Invoice title

Details about the fees autem vel eum
ullamcorper suscipit lobortis nisl ut a

Fees	£1,000.00
Sub total	**£1,000.0**
Vat @ 17.5%	£175.00
Total	**£1,175.00**

VAT number	123 4567
Terms	30 days
Account name	Isabelle A
Bank	Bank nam

I AM writing to you

A.N. Other
15 Some Road
Some Town
Some City
SE 14 9NJ

02.01.01

Dear A.N. Other

Title of letter

Start of letter, lorem ipsum dolor sit amet, consectetuer ad
mod tincidunt ut laoreet dolore magna aliquam erat volutpa
trud exercitation ullamcorper suscipit lobortis nisl ut aliqui
eum iriure dolor nulla facilisi. Lorem ipsum et dolor sit ame
ummy nibh euismod tincidunt ut laoreet dolore magna aliqu

Duis autem vel eum iriure dolor in hendrerit in vulputate ve
eu feugiat nulla facilisis at vero eros ets asccumsan iusto od
zzril delenit augue duis dolore te laoreet dolore magna aliq

Client>>Ruschenbaum
Design company>>HDR Design, UK

Brief>>Ruschenbaum is a German company manufacturing sanitary equipment such as water pipes and hoses. The name already existed, so UK-based HDR Design was asked to create a new visual identity for the company that would position it as a serious competitor in its market and differentiate it from its competitors.

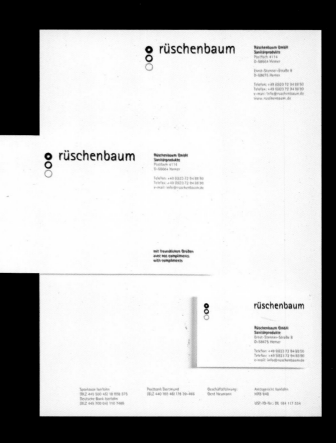

Solution>>The idea for the three circle abstract logo came from details of Ruschenbaum's products: cross sections of waterpipes and hoses. Hans Dieter Reichert has set the company name in lower case to integrate the symbol and give it a more unique impression using a Rotis sans serif typeface. This sans serif version has then been complimented by the serif version used as the main typeface for everyday correspondence.

Reichert has used the corporate colours of black and grey throughout the design to tone down the overall information. Black has been used to put emphasis on certain parts of the copy, but Reichert's intention was to keep the identity simple, elegant and sophisticated. HDR provided Ruschenbaum with a guide to laying out letters, but other application advice and guidelines were given verbally in training sessions with the members of administration, office and management staff.

Grids and Guides Process Interview
Client>>The London Hip Unit
Design company>>Simon and Lars, UK

Brief>>The Muirhead-Allwood Hip Unit is a specialist clinic based in London. When it moved premises in early 2001, doctors there asked London designers Simon and Lars to create an identity for it that would communicate the unique high quality specialist nature of the clinic and set it apart from other, more conventional London clinics. Client Dr Tim Nuthall wanted the patient-conscious approach of the private clinic to be conveyed in the graphic identity as well as the architecture and interior design, which was created by architect Angus Pond.

Developing the Identity>>Simon and Lars worked in close collaboration with Pond throughout the project to produce both the identity and interior design. They began by spending many hours researching and learning about the day-to-day practice of the hip unit and its radiography department, before drawing up mood boards and looking at colour schemes.

Firstly they felt that although the previous name was good in that it traded on Dr Sarah Muirhead-Allwood's reputation, the abbreviated Hip Unit could be a useful brand name and reflect the specialist nature of the clinic. This was developed as a logotype using a re-drawn version of Goudy Italic typeface.

"We were very keen to employ some elements that were friendly and not too sterile," explained Simon. "Goudy [typeface] was chosen for its personality and as the project developed the personality of the type form is celebrated in the materials produced."

THE LONDON

Miss S K Muirhead-Allwood
BSc (Hons) MB BS FRCS

Dr S Reed
3 Dukes Lane
London W8 4JL

25 July 2000

Dear Dr Reed

Re Mr Lars Amundsen DOB: 18/06/1971
55 Lockyer Estate, Kipling Street, London SE1 3RZ

Thank you very much for your letter about this 30 year old who gets increasing problems on negotiating stairs and when walking. The pain that he gets is in the right groin, going down to the knee and also in the trochanter. The pain has been there for 2 years but has got much worse over the last 6 months.

On examination the right hip flexes to 90° but rotation is irritable. He walks with an obvious limp. X-rays show marked loss of the joint space of the right hip which

Simon and Lars chose to use images of the sky – familiar to the patients in an otherwise baffling environment, as well as conveying the uplifting and optimistic mood of the clinic. The sky image was tinted with a number of different hues to give varied application options to The London Hip Unit's printed matter, including the front of the business card and the X-ray envelope. Simon and Lars worked with Pond using similar colours to tint the interior glass corridor that runs down the middle of the unit separating the offices, in order to connect the visual language of the architecture and graphic identity.

The move to new premises also meant that the graphics were potentially to be applied to areas as diverse as signage, multimedia, stationery, information booklets, X-ray bags, calendars, uniforms, packaging as well as the interior design. This was kept very much at the forefront of the designers' minds when developing all aspects of the identity.

Solution>>Completed in early 2002, the identity is based around a logotype made up of feminine letterforms of the Goudy typeface. The letters reflect the curved white walls of the unit designed by Angus Ponds, and the bowl of the letter 'P' becomes a handle for a bag in which X-rays are carried. The Hip Unit part of the logo has been blind embossed onto the letterhead, compliment slip and envelope but a secondary letterhead with the logotype printed in silver has been created for fax and other practical purposes.

The Hip Unit occupies the fourth floor of a hospital so a secondary '4flr' logotype was designed and set in cyan, the colour of the unit's floor coverings. It too has been applied to all addressed stationery and signage to aid orientation for patients visiting the unit for the first time.

Real care was taken with regard to the employment of the identity on print matter, graphics and signage. The designers were careful not to stamp the identity indiscriminately on everything. Instead, application of the identity has been carried in a more sympathetic manner, for instance, in the use of subtle blind embossing.

THE LONDON

Hip Unit

Miss S K Muirhead-Allwood
BSc (Hons) MB BS FRCS

THE LONDON

THE LONDON

Hip Unit

THE LONDON

X-ray

Hip Unit

THE LONDON
Hip Unit

Application
110>151>>

Introduction>>

The application of an identity onto stationery brings it to life and gives the opportunity to add another aspect to its design. A thought-through application can help a design concept evolve from being just another business card or letterhead. There is an endless variety of application techniques available to the designer, and making use of them is an important part of the whole design process.

Even within the choice of paper stock, there is an almost infinite variety available; un-coated, coated, translucent, coloured and recycled to name a few. There may be standard paper shapes and sizes but by incorporating a fold or cut into the design the designer can give it a third dimension. On the other hand, why use paper? There are many other materials to print on including metal and plastic.

Embossing, debossing or foil blocking a company logo onto a set of stationery can bring a sense of quality to a design. Similarly, printing using the low-tech letterpress technique rather than litho can also lend a certain sense of distinction to a letterhead or business card.

The clever use of imagery is another way to bring a design to life and give a company a strong and recognisable identity. Over the following pages is a variety of the more unusual applications used within the design and creation of a set of stationery – those that are a little more experimental and have not stopped at the expected.

Above>>T.26 business card by
SEGURA INC, USA.

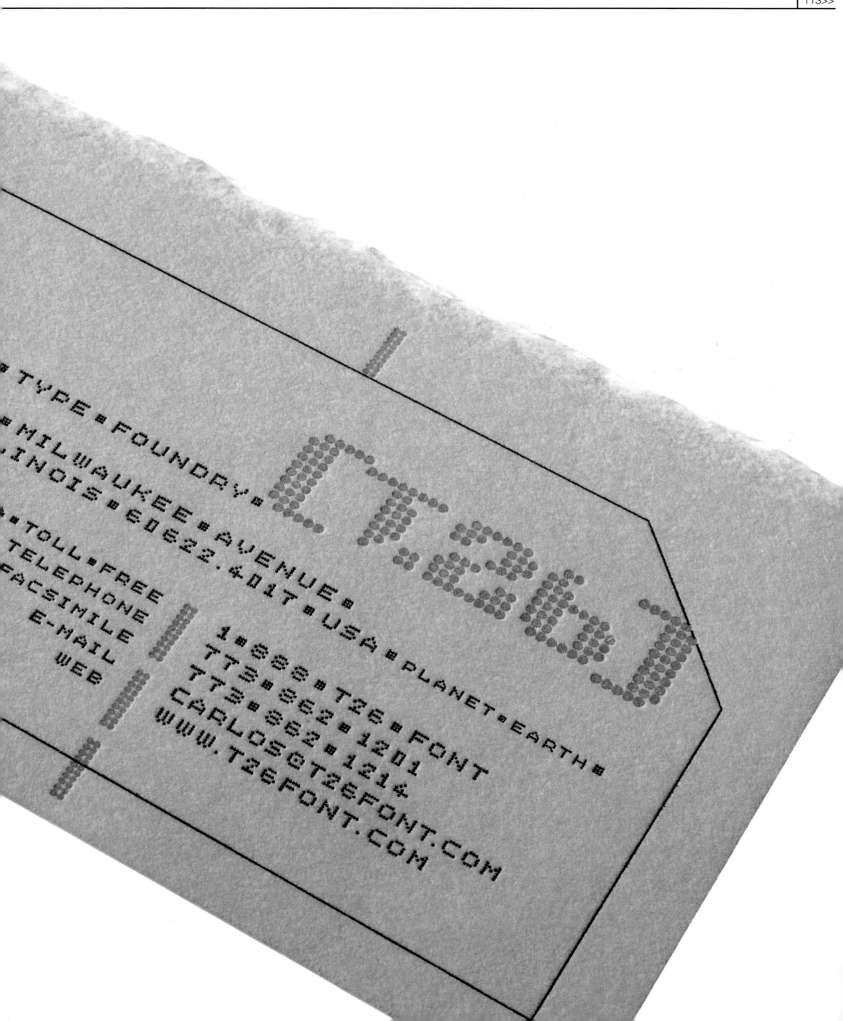

[t26]

■TYPE■FOUNDRY■
■MILWAUKEE■AVENUE■
■ILLINOIS■60622.4017■USA■PLANET■EARTH■

■TOLL■FREE 1■888■T26■FONT
■TELEPHONE 773■862■1201
■FACSIMILE 773■862■1214
E-MAIL CARLOS@T26FONT.COM
WEB WWW.T26FONT.COM

do© is an ever-changing brand that dep

Materials

Paper>>The first ever sheets of paper were made in China in around 200 BC. Since then, it has become an indispensable medium and today there is a great variety of stocks available in different weights, colours and finishes.

There are internationally recognised paper sizes but they vary from country to country. The Japanese letterhead usually measures 21 x 26cm; the American is 8.5 x 11in. The Europeans use the Deutsche Industries Normen (or DIN) system, devised in Germany in the 1920s. The European letterhead size A4 – which at 297 x 210mm is the 476 standard – refers to this system. Business cards are A7 in the DIN system, or 105 x 74mm, while envelopes are covered by the C series.

Letterheads say a lot about the quality of a company, and it is often the first encounter a client has with a company, so the choice of letterhead and business card paper is important. Paper companies produce papers with finishes such as corrugated, marbled, metallic-coated, plastic-coated, translucent, patterned translucent and even whole sheets embossed with a particular pattern.

The use of such papers is becoming increasingly popular with designers, as the choice of paper for a set of stationery has become as important as the choice of typeface. It is an aspect of the design process that is often not given enough consideration, yet it has the potential to make the difference between a good and a particularly special design.

As designers become more experimental with paper, printers and paper companies are becoming more experienced and equipped to accommodate special requests.

The use of an unusual paper can mean incurring extra costs in production but is well worth it if the budget allows. Some special papers that you would assume are expensive are often not so, and therefore it is worth looking into prices before writing them off as a non-viable option.

Certain papers lend themselves better than others to certain printing processes or special effects, but the designer is by no means restricted to what are known as office papers when printing a set of stationery. These tend to weigh around 110–115gsm but using a heavier or lighter stock, each of which has unique benefits, can have positive client benefits. However, one point to consider is that if you use a stock that is too heavy or too light, then the letterhead won't go through a LaserWriter correctly. Also, if it is heavy then large mail-outs can incur significantly higher costs.

lauriergracht 39
1016 rg amsterdam
p.o. box 3240
1001 aa amsterdam
the netherlands
phone +31(0)20 5301070
fax +31(0)20 5301061
e-mail domail@dosurf.com
website www.dosurf.com

it you do.

A lightweight, transparent paper was used for a stationery system designed by Dutch agency KesselsKramer for Do, an ever-changing brand – sometimes a furniture collection, sometimes an exhibition, sometimes a website, sometimes a book. Designers at KesselsKramer used Rijnbank 50g/m2 stock supplied by Bührmann-Ubbens Paper in the Netherlands. It was chosen for ease of folding as each letterhead instructs the recipient, with the help of images, to actually make something out of it.

Hans Dieter Reichart of HDR Design has used a translucent Simulator stock for a stationery system for Glasshammer, a model-making and production company working in advertising and architectural industries. "I have tried to reflect the name Glasshammer and its business in the logo and the use of a glassy, semi-transparent paper," explained Reichert. "I wanted something that would stand out and since they work with various materials felt that using a transparent paper would definitely contribute to their individual appearance."

Left and Above>>Stationery for
Do by KesselsKramer.
Right>>Glasshammer stationery
by HDR Design.

Amsterdam-based designer SWIP STOLK chose to use a plastic-coated Chromekote 115gsm stock for Dutch computer artist Micha Klein's stationery system. The letterhead is coated only on the reverse to enable ink to be absorbed on the front. It also features the company logo embossed and coated in a white foil. The logo on the compliment slip is again embossed and coated in white foil while the business card is plastic coated with a thicker soft plastic case.

MICHA KLEIN
HERENGRACHT 384sous
1018 CJ AMSTERDAM THE NETHERLANDS
Tel: +31(0)20-6262666 Fax: +31(0)20-6268477
Mobile: +31(0)18-5471857

Internet: http://www.michaklein.com
e-mail: micha@michaklein.com

Left>>Micha Klein business cards by
SWIP STOLK. **Bottom>>**New Art
Gallery Wallsall stationery designed by
Michael Nash Associates.
Above>> A Folded copy of Linija
letterhead by Lithuanian
designer Ausra Lisauskiene.

In contrast, recycled papers offer a natural tone and texture that can be as smooth and white as non-recycled paper or if earth coloured, very self-evidently recycled. It is worth noting that some recycled stocks tend to absorb ink, so allowances will have to be made when considering ink type and type size. They can also be slightly more expensive than conventional papers so investigate first.

Again, recycled paper is not suitable for all clients but it can show their concern for the environment and can be used in almost exactly the same way as conventional paper. Its advantages are shown well in a stationery system for Portuguese photographers Ana Pedrosa and Antonio Sa (page 143) designed by R2 Design, Portugal, and also in the identity for The New Art Gallery, Walsall, UK designed by London designers Michael Nash Associates (left).

The gallery itself was created by architects Caruso and Peter St John who used a very simple palette of materials including untreated concrete, wood, stainless steel and leather. The gallery identity interprets this same plain-talking visual language using natural and recycled stocks, left either undyed or untreated, together with an odd-weighted font to maintain the overall unpolished effect.

Linija was an international exhibition on the subject of Tapestry held in 1999 in Kaunas, Lithuania. Lithuanian designer Ausra Lisauskiene has taken names of exhibiting artists and printed them in green on a transparent sheet of paper that is attached to and sits over the letterhead designed for the exhibition. The logotype was created by cutting out the shapes of the letters from exhibited textile work.

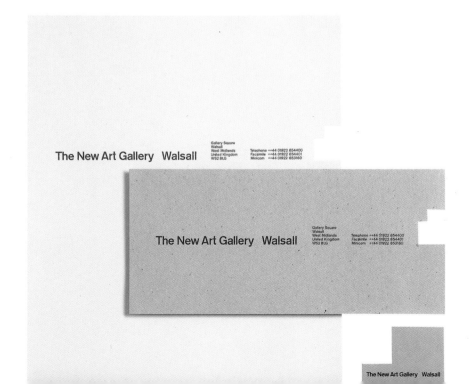

The New Art Gallery Walsall

Gallery Square
Walsall
West Midlands
United Kingdom
WS2 8LG

Telephone ++44 01922 654400
Facsimile ++44 01922 654401
Minicom ++44 01922 653160

Plastic>>Paper is the usual and most practical choice of material on which to print a stationery system, but there are other options. Their use will not be suitable for all clients, but for those who are willing to try something different, plastic, metal or even cloth are exciting possibilities, both unusual and highly durable.

However, within the stationery set it is usually only the business card that will be printed on any material other than paper simply because it would otherwise be impractical. A plastic or metal letterhead will not go through an average office printer and can not be written on by hand. Such materials are more widely used in other areas of design such as brochures, invitations or books.

Printing on such material will require special printing techniques and a printer that has the skill to deal with the job, but there are a growing number of printers willing and able to take on such jobs and produce stunning results. Among them is UK-based specialist printer Artomatic. Over the page is a silkscreen printed polypropylene business card for London design agency Insect. Using glow edge polycarbonate, Artomatic has also silk-screen-printed the brightly coloured eye-catching business card for stylist William Baker that was designed by Tony Hung at Adjective Noun.

SEA Design chose to print the business card for chartered accountants Ward Williams (below) on plastic, purely for point-of-difference. It was more expensive but felt worth it and the budget allowed for it. The card features contact details on one side and photographs of the directors on the other. It has been printed using silk-screen inks in the company's corporate colours.

Bottom Left>>Ward Williams business card by SEA Design.
Right>> Stationery for Elevation desiged by SEGURA INC, USA.

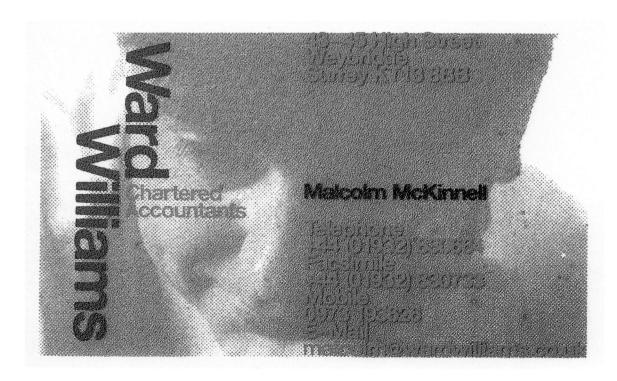

elevation

elevation®

eric heneghan | ceo
eheneghan@elevation-inc.com | 312.640.8501

440 west ontario street | chicago | illinois | 60610 | usa
312.640.8500 v | 312.573.4003 f | www.elevation-inc.com

elevation®

never trust a stylist

never trust a stylist

never trust a stylist

ex 020 7813 1913 Email Alexdex2000@aol.com VAT No 756 4241 25

INSECT 1 - 5 Clerkenwell Road London EC1M 5PA
T 020 7253 0533 F 020 7253 0053 fly1@insect.co.uk www.insect.co.uk

1 - 5 Clerkenwell Road
London EC1M 5PA
T 020 7253 0533 F 020 7253 0053
M 07956 337 840 luke@insect.co.uk
www.insect.co.uk

Left>>Stylist William Baker's stationery
by Tony Hung at Adjective Noun
Right>>Stationery for and by designers
at Insect.

LUKE DAVIES

Surface Effects

There is an enormous range of surface effects available to the designer, through printing techniques and treatments that can add both character and a feeling of quality to the stationery set. From spot varnish and scratch cards to embossing, the options are endless and although they add extra costs to production, can prove well worth it.

Foil Blocking>>is a technique often used on a company letterhead to highlight the logo or company name. It is a subtle effect but draws attention to a letterhead or business card and makes it that bit more special. It is achieved by applying a thin layer of metal or foil to the surface, using a metal block, heat and pressure to produce a smooth shiny finish.

Despite the option of spot varnishing metallic inks, foil blocking is the best way to achieve a truly metallic look. Foils are available in many finishes including satin, gloss and matt, and an expanding range of metallic colours includes clear, iridescent and pearl.

Designers at Atelier Works have used foil blocking to apply the dotted identity created for their client RSA Art for Architecture. Although it added a little extra cost to production, the effect was unexpected and therefore more memorable. The process works on conventional 110gsm stationery paper, as do the other applications Atelier Works have used to apply the dots including embossing, varnishes and blind debossing.

When Browns was commissioned to create an identity for Spacecraft, a design consultancy specialising in interiors, the designers chose to foil block the logotype onto the letterhead, compliment slip and business card using a mirror finish. They chose to use this technique not only for point-of-difference but also to say something about how the company works.

"The idea is that whatever the environment or project Spacecraft designers find themselves working on, similar to the identity, they reflect that environment perfectly," explained Jonathan Ellery at Browns. The foil blocking of the Univers type was applied to Taffetta paper with urban photographic abstractions printed on the back of the business cards as a secondary visual language.

London-based designers HGV have also used the foil blocking technique to apply the 'W' of client Watermans' logo. Designer Pierre Vermeir chose a gloss foil for the letterhead of this Arts Centre. Again, foil blocking is a job that will need a specialist printer, but there are many that can accommodate it at a relatively low cost.

spacecraft

Left and Above Right>>Spacecraft identity by Browns/London. **Middle Right>>**RSA logo designed by Atelier Works. **Bottom Right>>**Watermans logo designed by HGV.

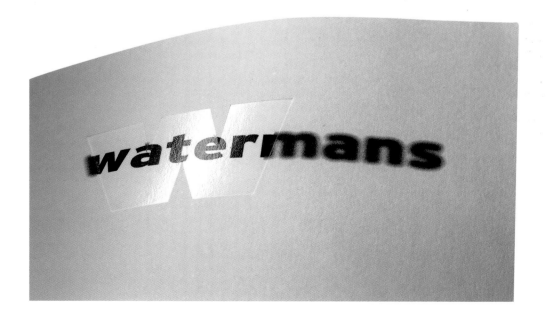

Embossing>>is a technique well used by designers in all areas of design, including the application of a logo or logotype on the stationery system. By creating a raised surface pattern it adds another dimension to a sheet of paper, making it both appealing to the eye and to the touch.

It is achieved by pressing the paper or card between a male and female metal die. The technique requires a thick weave and uncoated stock which will prevent cracking and enable the embossing technique to reach its full potential. If the pressing process is reversed the image produced is sunken into the paper or card and is known as debossing.

Bevelled, rounded or faceted dies are available for embossing and are made to measure depending on the depth and shape of embossing required. When embossing it is advisable to consult your printer before finalising the choice of stock.

Blind embossing is created using the same process but without foil or ink. Instead, the image is made visible by the shadows it casts, demonstrated well by Box Studio's identity (below), created by Atelier Works, London. The bespoke typeface, designed from a series of hand drawn box shapes, is based firstly on the idea of a camera box, and secondly on the studio spaces themselves, described by Quentin Newark, one of the Principals at Atelier Works, as essentially being boxes or white shells.

A thick weave paper has been used in order for the embossing technique to realise its full potential, which features on all printed matter including business cards, letterheads and leaflets. The blind embossing technique also means that the logo is made and seen by light and shade which is the essence of the work completed by this photographic studio.

London-based Glazer design has combined embossing and debossing for the stationery system of client B and H (right), The Colour Change Company. The 'B' is embossed and the 'H' debossed to Cx22 stock. Although this is not a particularly thick weave paper, tests were carried out beforehand to ensure that the grain on the paper would not splinter during the embossing process.

Bottom Left>>Box Studio's stationery by Atelier Works.
Right>>B + H The Colour Change Company logo by Glazer design.

BOX 15 Mandela Street London NW1 0DU
T 020 7388 0020 F 020 7387 4259
E mail@boxstudios.co.uk W www.boxstudios.co.uk

B+H The Colour Change Company

Jessica House Red Lion Square
London SW18 4LS

T: +44 (0)20 8877 1233
F: +44 (0)20 8877 0784
E: team@liquid-crystal.com
W: www.liquid-crystal.com

with compliments

MUSEUM✚HET REMBRANDTHUIS ✤

Jodenbreestraat 4, 1011 NK Amsterdam · telefoon +31(0)20 – 5200400 · fax +31(0)20 – 5200401 · Postbus 16944, 1001 RK · e-mail: museum@rembrandthuis.nl

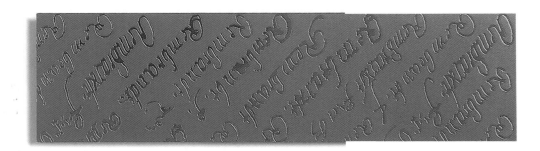

ABN AMRO Bank 46.67.54.175 / Postbank 27 81 83 t.n.v. Stichting Rembrandthuis

Dr. med. & Dr. phil.

MARIO B. ROBBIANI-FREY

Facharzt FMH *für* GYNÄKOLOGIE & GEBURTSHILFE

Marktgasse 4, 4051 Basel, T 061 261 35 10, F 061 261 35 16

Left>>Stationery for Rembrandt Museum by SWIP STOLK. **Above>>**Dr.Med and Dr.Phil business card by Swiss designers Wild and Frey.

Swiss designers Wild and Frey have also used the blind embossing technique for the application of gynaecologists Dr. Med and Dr. Phil logo (above). They wanted it to be honest and trustworthy in an understated way, as well as understandable and interesting to both patients and other doctors. The female chromosome set logo has been blind embossed between the dark Anthrazit type.

Blind embossing has its advantages in that it is tactile, visually attractive and clean but it is important to consider how it will work when using a fax, or on the web. A logo that is easily translatable onto those media by creating a colour version of it is essential.

Dutch designer SWIP STOLK has applied Amsterdam's Rembrandt Museum logos to communications using a copper foil emboss. They have used this method as it directly relates to the copperplates that Rembrandt used for his etchings. It also lends a sense of quality to the overall feel of the stationery.

Die-Stamping>>is essentially a combination of embossing and gloss or matt coating. The recess created by the metal die is coated with a gloss or matt ink of any colour, producing a satisfyingly accurate result.

It is a process that tends to lend itself better to matt or uncoated papers, which is what designers at London-based agency Real451 used when creating a logo and stationery system for photographer Julian Cornish Trestrail. The contact numbers have been die-stamped with a clear gloss varnish on the letterhead, creating an intriguing identity.

However, it was not possible to achieve such a result on the business card because the contact numbers needed to be clear, and technically, this is virtually impossible to achieve at such a small size. The colour of the Julian Cornish Trestrail type is derived from the yellow marks found on 35mm film.

Right>>Julian Cornish Trestrail letterhead by Real451.

nish Trestrail
ny
se Studios
nion Street
1 OLH

01 9090

360 677 698

928 8599

Letterpress>>Letterpress is the traditional relief printing process in which ink is applied to the paper through pressure using raised blocks of type. The images or letters are pressed onto the sheet leaving an impression, and although fairly low-tech compared to litho printing, it is still a popular method of printing.

It has a particular quality that is still favoured by many designers and used when appropriate on clients' communications. Vince Frost at London-based agency Frost Design, used the technique in an identity for 400 Films (see pages 64–65). Similarly, Atelier works have used the process to apply words to client The Print Room's communication.

The Print Room is a company that sells art, so designer Quentin Newark thought it seemed appropriate to devise a graphic identity that used unusual print techniques. The idea is that each item of communication is unique and made by hand, using exactly the same processes as the prints the client is selling.

Above>>The Print Room identity by
Atelier Works

Rubber Stamps and Stickers>>A relatively low-tech approach which possesses a certain charm as well as budgetary advantages is the hand-held stamp. It works as an effective and quite distinctive application and has the added advantage of providing a client with a logo that they are free to apply to any material anywhere, anytime. It works on the same principle as the Fly Productions sticker system shown overleaf.

Swiss designers Wild and Frey have employed the technique to create an identity for photographer Pascal Wüest. He asked the designers to develop a simple but effective identity system that would allow him a lot of freedom in use. The result is a logo and address in one circular shape representing the viewfinder of a camera. Wild and Frey provided Wüest with an ink pad containing two colours, black in the middle and red for the outer circle, and a stamp which he uses to apply the logo to his letterhead or business card when he needs to.

Similarly, UK designers Glazer have created a stamp for Ampersand, a small business run by Virginia Banks who makes words and pictures from old wooden printer type blocks. Banks required an identity that was not too expensive, hence the stamp. The design solution has two aspects: firstly David Jones, creative director at Glazer, has created a logo that draws on both the shape of an ampersand and the 'B' from Banks. This has then been embossed onto a brown card which was as near as possible to a weathered piece of wood. During the embossing, it was double hit to create a sharper, deeper effect. To keep costs down, the logo was made into a rubber stamp which can be applied when required to plain paper, creating a letterhead or invoice.

Virginia Banks **AMPERSAND** 59 Altenburg Gardens London SW11 1JH **Tel/Fax** 020 7564 4550

Left>>Logo for Pascal Wüest by Wild & Frey. **Right>>**Ampersand business card by designers at Glazer.

Fabian Monheim and Sophia Wood of Fly Productions have created an identity for their design company that is based on the idea of versatility and mobility. Essentially, they wanted something that would be ever-changing and easily applied. The logo itself, which is the Japanese word for Fly written in Chinese style, was given to them by one of their clients in the form of a handcrafted stamp.

Fly Productions still uses this stamp to apply the identity to all manner of material, whether it be a sheet of paper to be used as a letterhead or a page in someone's filofax. The designers have also created a sticker system based on the same principle which contains the company's contact details.

Swiss designer Martin Woodtli also chose to create a sheet of stickers instead of a traditional business card for photographer client Katharina Lütscher – a versatile option for clients that are open to different ideas.

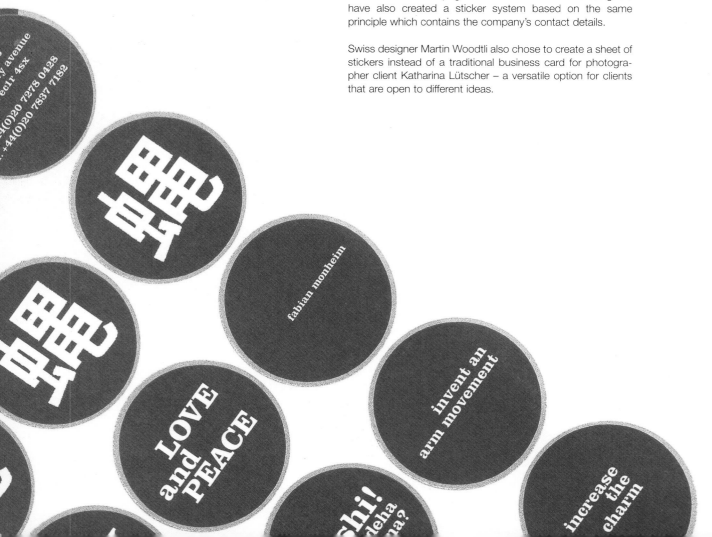

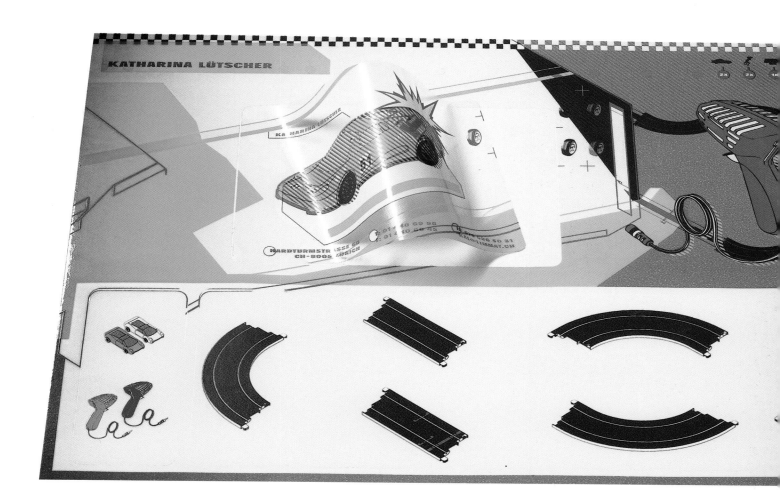

Left>>Stationery for and by Fly Productions. **Above>>**Katharina Lütscher business card designed by Martin Woodtli.

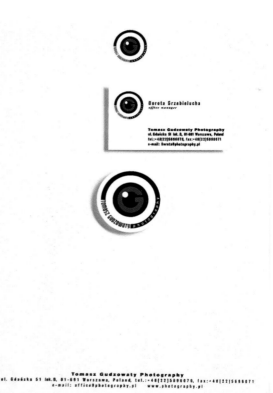

Raised Print/Thermography>>Thermography is a less expensive alternative to die-stamping and gives a similar result only without the impression on the back. After offset printing, while the ink is still wet, a fine resinous powder is applied to the ink to give a glossy or dull finish.

The sheet is then passed through a heat chamber that fuses the resin into a raised image, and to make it safe for laserprinting it is then passed through a second heat chamber that applies ultraviolet light – heating it to a much higher temperature.

Designers at KOREK Studio, Poland, have used the thermography process to apply to all elements of photographer Tomasz Gudzowaty's stationery. "I like this printing," explained designer Wojtek Korkuc. "The colours are stronger than when using offset printing and it gives it a plastic-like effect, something different from flat printing."

Left and Right>>Stationery for Tomasz Gudzowaty Photography by designers at Korek Studio.

SENSUS DESIGN FACTORY
· Kristina Špoljar

Siječanjska 9 Zagreb HR-10000 Croatia

Scratch Cards>>Scratch-off coatings are more commonly associated with lottery scratch cards or mobile phone top-up cards, but the effect is often used by designers to add another dimension to a business card or letterhead.

The common process is to litho print an image or text onto the desired material and then silkscreen print the scratch-off coating on top to hide it.

Shown here is the business card of Croatian design company Sensus Design Factory based in Zagreb. Having recently moved to a new studio, co-founder Nedjeljko Spolijar wanted to create a business card that would force the reader to have to do something in order to get the agency's contact details.

"We thought, why not make cards that forced people to do something to get our phone number," Spolijar explained. "If one really wants it he can get it and that one is the client that would really want to work with us...We considered this to be an appropriate way to see if people got the point and to keep the loyal guys with us."

With a different idea behind it, but working on the same principle, Dutch designer Peter Heykamp has created scratch off business cards for Cheap 'n' Nasty, an image manipulation company.

Owner of Cheap 'n' Nasty, Nick Strong, wanted to make a statement through the scratch cards by writing on them "Limit your scratching". This refers to the fact that although regular lottery scratch cards are cheap to buy, they are unlikely to bring you a fortune.

Underneath each scratch zone it reads: 'If underneath the scratch-layer you find a cheap-n-nasty image, you loose. You can't win. Prevent gambling addiction. Scratch limited'. The printing process was long and took a number of trial runs to get right but eventually worked out, and now each card consists of seventeen printed layers and one scratch layer.

WE LOVE YOU

WE LOVE YOUR MONEY

SENSUS DESIGN FACTORY

SENSUS DESIGN FACTORY

Dobrinjska 25 : Zagreb HR-10000 : Croatia
t+f 385 1 3049010 : m 385 98 1874643
kristina.spoljar@post.hinet.hr

Left>>Stationery for and
by Sensus Design Factory, Croatia.
Right>>Cheap 'n' Nasty business
cards designed by Peter Heykamp.

Inks>>There are many inks available on the market today, and if you take full advantage of them, the relatively small extra cost can transform a design. From luminous and metallic to thermally sensitive ink, the range is ever-growing.

Spanish designers Lamosca chose to use metallic ink when printing Barcelona-based architecture studio 22a's stationery. Designers have based the identity on a rectangular system to reflect the mathematical accuracy of the architect's job and then adapted the shape to the system in varying sizes.

British agency Nevis Design has also used metallic ink for the application of human resource development consultants Change. The silver ink works well against the stark white background making a clean and sophisticated stationery system. The 'g' has been reversed to hint at the transformative nature of Change's business which is to help employees develop the skills and understanding that their employers need.

Although foil blocking is the only way to achieve a convincing metallic effect, metallic inks are only marginally more expensive than standard inks and require no special printing process.

Above Left>>22a stationery designed by Lamosca, Spain. **Bottom Left>>** Change Management logo designed by Nevis Design. **Above Right>>**Gilbert logo and stationery designed by Thirstype, USA.

US designers Thirstype worked with their printer to create a proprietary colour for the application of paper company Gilbert's logo, as they were not able to find a suitable colour within the Pantone range. The slightly raised logotype has been engraved rather than printed by US printers Artistry Engraving. Together with the usual format letterhead, a smaller format letterhead, known as a monarch, has been produced for the upper tier of the management at Gilbert. This smaller format is not uncommon in the USA.

mtv.com

770 Broadway
New York NY 10003
phone 212 / 654 96 93
fax 212 / 654 90 69
amie.rothstein@mtvi.com

Amie Rothstein
Manager, Retention Marketing

Heat Sensitive Ink>>The use of heat sensitive ink has become increasingly popular and can produce striking results that really engage the reader. The usual process is to litho print an image or text onto the desired material, and then over-print with the heat sensitive ink using the silk-screen printing process.

Artomatic used this process when printing MTV's business cards which were designed by CoDe Design, New York. The ink colour changes depending on the intensity of the heat and eventually reveals, in this case, the frog images beneath. The ink can be specially made to react to different temperatures and the effect it produces can be, and is, used in many ways to produce fun and visually interesting work.

Above>>MTV.com business cards by CoDe Communication and Design, New York.

Repórteres Freelance
Rua 33 | 1253 | 5º DF
4500 - 313 Espinho | Portugal
Tel/ fax +351. 227 346 191
Email: asapfoto@mail.telepac.pt

antónio sá + ana pedrosa

Manipulation>>

Bottom>>Factory stationery
designed by Atelier Works.
Above Right>>Amanda Wakeley
identity by designers at Pentagram.
Above Left>>António Sá and
Ana Pedrosa identity by
R2 Design, Portugal.

Die cutting>>Die-cutting is a highly effective printing technique and can transform a two-dimensional piece of paper to give it a dramatic design impact. It is fairly inexpensive at its most basic level but will cost slightly more if you use the laser cutting method. This can produce amazingly intricate and detailed images.

Designers employ the technique in a variety of ways, from a simple straight line to a series of holes intended to mimic stamp perforations.

When John Powner at Atelier Works suggested to product design client Factory that they have a business card with a hole in, they were slightly shocked and had concerns over practicality. However, they saw the conceptual strength of a third dimension and went with it.

Powner has used a quality white board stock with a matt laminate that also helps stop fraying. The idea is that, depending on how you hold the card, the die-cut can be seen as either an 'F' or as a factory with chimneys.

Creatives at R2 Design, Portugal, have used the die-cutting technique for freelance photographers Ana Pedrosa and António Sá, who photograph and write for several magazines, including the Portuguese version of National Geographic magazine. As they are both environmentally caring people, recycled stocks have been used with only one colour so the use of blind embossing and die-cutting adds something a bit special.

The cut has the same form as camera film and has been used for obvious reasons. To compliment this, and because the clients work all around the world, a blind embossed infinity symbol on the letterhead was felt appropriate.

John Rushworth, partner at London-based designer Pentagram has used a very subtle die-cut on the letterhead of fashion designer client Amanda Wakeley. Her name is set in a bespoke font with a diagonal cut in the paper between the two words. The cut refers to the bias cutting in Wakeley's tailoring and was translated into a simple line where necessary. This simple device was then applied to all elements of her identity system, including stationery, carrier bags, wrapping paper and swing tickets.

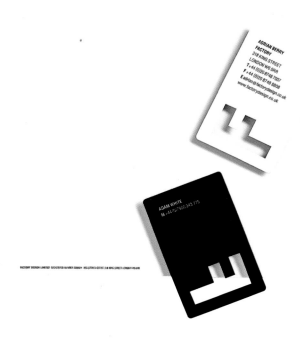

REAL451

102 dean street london w1d 3tq t. 020 7851 1390 f. 020 7851 1391 url. www.real451.com isdn. 020 7851 7489

London design company Real451 have used the die-cutting technique to create stamp-like perforations within their own A4 letterhead. The idea is to prevent waste of paper and so, by using the perforations, the letterhead can be broken down in to a compliment slip, business card and smaller letterhead.

In addition, it also means that once received, a business card can be torn off and used as a record of the sender's contact details and demonstrates innovative design making a point-of-difference.

Digital Print is a Zurich-based printer specialising in unusual printing techniques. When asked to create an identity for them, Swiss designers Wild and Frey created a simple logo based on the name and address, but applied it in a number of different ways to demonstrate the services that Digital Print offers.

The logo has also been applied to a matchbox in the place where you light the match. To ensure its clients see the whole range, the stationery is mixed – a die-cut letterhead goes with a debossed business card in a embossed printed envelope with a silk-screen printed sticker attached.

Right>>Digital Print stationery designed by Wild & Frey.
Above and Below>>Stationery for and by Real451, London.

DIGITAL PRINT ZÜRICH AG

RAUTISTRASSE 71 8048 ZÜRICH

TEL 01 40 40 00 FAX 01 40 40 20

DIGITAL PRINT ZÜRICH AG

RAUTISTRASSE 71 8048 ZÜRICH

TEL 01 40 40 00 FAX 01 40 40 20

work

Folding>>Graphic design is often wrongly thought of as two-dimensional, but on a closer look, stationery, most obviously letterheads, operates in three dimensions and is designed to be folded. Folding can be used in stationery design to add a third dimension for both function and fun. It might be used to accommodate a particular typeface or merely to make it more memorable.

Here you see how designer Yorgo Tloupas has created business cards that can be folded to create vehicles for those working on the UK car magazine Intersection. His design ties in well with the magazine, which takes a different look at the world of cars. Tloupas also wanted to revive the excitement one gets as a child when given a toy car and raise a smile from those who receive it.

This innovative business card has proved an undoubted success, since recipients invariably begin to fold it and play with it and then apologise for having to give a standard card in exchange. Ten individual vehicle business cards have been designed for the employees of Intersection, each of which is in some way relevant to their personality.

London design studio Atelier Works has used the idea of folding paper to maximise the information it can include on its business card. The card (shown above) folds out to become six times the size, revealing a series of images of recent projects completed by designers at the agency as well as contact names and numbers.

Right>>Intersection business cards designed by Yorgo Tloupas.
Above>>Business card for and by Atelier Works.

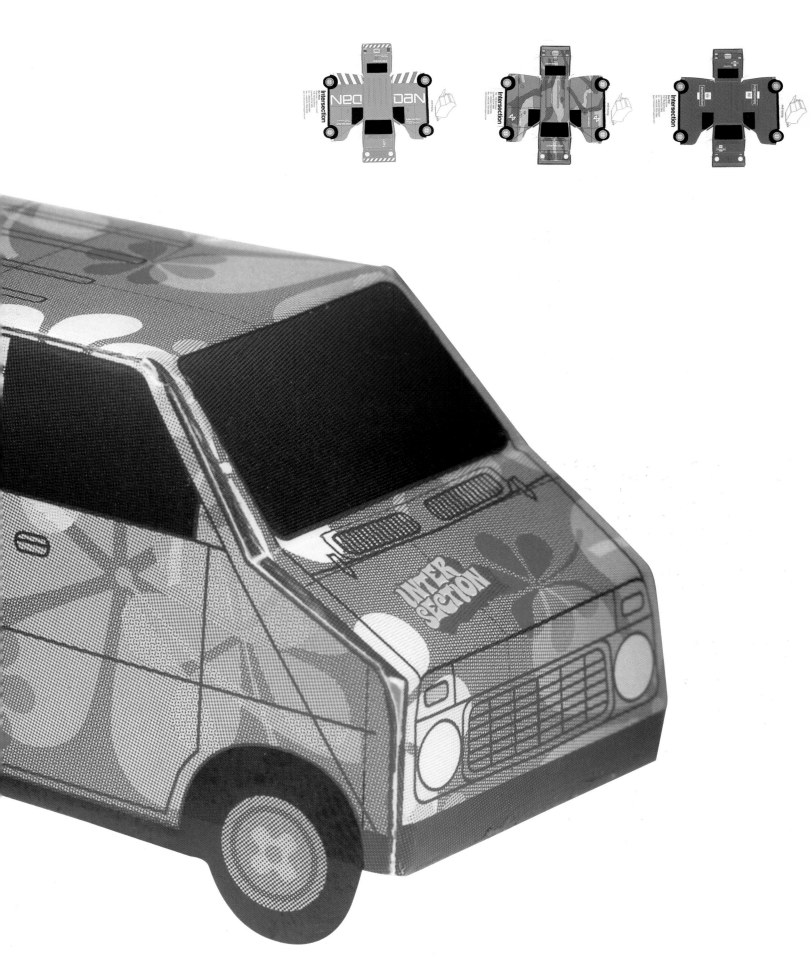

Paper Shape and Size>>National or international standards not withstanding, designers are also free to experiment with paper shape and size, as both Dutch designers KesselsKramer and London-based Johnson Banks have done with stationery sets for Little Pete and Lapis respectively.

For marketing communications company Lapis, designers at Johnson Banks have chosen to use the unconventional 210mm by 210mm paper size for the letterhead, 10mm by 10mm for the compliment slip and 55mm by 55mm for the business card. Taking the word Lapis, which is Greek for stone, the deisgners created a visual identity that simply worked best on that format, so the paper was cut to fit.

Similarly, for 4ft tall UK actor Little Pete, Dutch design agency KesselsKramer has used an even smaller paper size as a play on the actor's height and to gain him attention.

Lapis marketing communications 1 Marylebone Mews London W1M 7LF
telephone 0171 224 0535 facsimile 0171 224 0536 mobile 0836 273315

Above>>Lapis stationery by Johnson Banks. **Right>>**Little Pete stationery by KesselsKramer (outline shows the size of a normal A4 letterhead).

LITTLE
PETE
actor (4ft .)

LITTLE
PETE
actor(4ft.)

LITTLE
PETE
actor (4ft.)

tel 0860 865752
17 High Street Old Town Poole-Dorset BH15 1AB

Similarly, for 4ft tall UK actor Little Pete, Dutch design agency KesselsKramer has used an even smaller paper size as a play on the actor's height and to gain him attention.

Type and Imagery>>Although I have covered the use of typography and imagery in previous chapters, I felt that the two examples featured on this page were also worthy of inclusion. Neither set of stationery features a surface effect or use of special paper, but instead shows that clever use of illustration and type is another way to bring a design to life and give a company a strong and recognisable identity.

Designers at UK-based DA have used digital binary code to create illustrations of Hollywood actors on the reverse of stationery for home cinema specialist client Cinemastyle. The Gridnik typeface was used for its ordered simplicity which allows it to create such images as Tom Cruise playing Jerry Maguire, in the eponymously titled film. This image has been used on the reverse of Cinemastyle's invoices. The paper shape and size also works with the cinema theme by conforming to the wide-screen ratios of cinema screens.

Above>>Cinemastyle stationery designed by DA. **Right>>**Stationery for and by Airside, London.

Illustration is a great way to add colour and life to stationery and make it highly personal. To the left is a set of stationery created in-house for London design agency Airside. Each business card features a computer-generated illustration of a member of the team. These were created by director Fred Deakin and Alex Maclean. It is a strong and playful identity that draws the reader in, which is ultimately what all identities should do.

Law

The law relating to trademarks and the registering of trademarks varies from country to country, so this is not a definitive guide. However, certain information relating to how to go about registering a trademark, establishing whether a new name or mark is free for use, and the designer's responsibility within that area, will be similar around the world.

Corporate clients with larger companies will usually have their own lawyers to register trademarks. Similarly, larger design offices, especially those who specialise in branding, will also register trademarks on behalf of their clients. Smaller design studios are not normally solely responsible for registering trademarks but it is good to have some knowledge for either your own benefit or your clients' on how the law of trademarks works.

The United States Patent and Trademark Office defines a trademark as "a word, phrase, symbol or design, or combination of words, phrases, symbols or designs, which identifies and distinguishes the source of the goods or services of one party from those of others. A service mark is the same as a trademark except that it identifies and distinguishes the source of a service rather than a product. Normally, a mark for goods appears on the product or on its packaging, while a service mark appears in advertising for the services."

It is not essential to go through a trademark attorney to register a trademark or design, but it can be helpful as registering a trademark can be quite complicated and time consuming. Attorneys will deal with it all for you for a reasonable fee, although it will depend on what territories you want the trademark registered in. For international registration, you may have no choice but to use an attorney.

In the USA, the United States Patent and Trademark Office is the regulating body (website details opposite). Here, they give you advice on how to go about registering a trademark yourself with helpful information on the law, search services and registration forms. It is similar in the UK, Europe,

Australia and the rest of the world with each country having a central office or governing body (some more links and contact numbers opposite).

If registering a trademark without an attorney, it is important to consider that the scope of protection you get will depend on your application so it is important that you get this right. Trademarks are examined to see whether they are a) distinctive enough and b) not too close to something already on the register. Designs undergo only a basic formality examination. If there is a chance of filing outside your home country, it is advisable to take specialist advice on all the different routes to protection.

Once you start to build up a portfolio of trademarks an attorney will play a valuable role in co-ordinating this and taking care of all objections raised and the renewal fees due. They can also run watches to see what others are trying to register. Importantly, your attorney can advise on the freedom to use a particular mark before committing to the expense of protecting the mark by arranging searches and advising on the results.

They also work with counterparts around the world to secure protection outside of your home country. There are international conventions which set up different ways to protect designs, and attorneys are able to guide clients through the alternative routes to protection.

The central organisation in the UK is the UK Patent Office (website details opposite). It describes a trademark as "any sign which can distinguish the goods and services of one trader from those of another."

As I said before, using an attorney is not essential, but most firms of attorneys offer a short consultation that is a good way to explore the rights available to you and tailored to the particular project. It does help if you go to this consultation having done a little homework beforehand, as it will mean you gain more from the meeting.

Recommended information resources on Law and Trademarks.

>>The UK Patent Office: www.patent.gov.uk

>>The Institute of Trademark Attorneys in the UK is a good place to look for a registered trademark attorney in the UK and there are similar bodies in every country: www.itma.org.uk

>>The US Patent and Trademark Office can be found at www.uspto.gov. Here you will also find the Trademark Electronic Business Centre which is a one-stop source for all online trademark searching, filing and follow up in the USA.

>>The World Intellectual Property Organisation (WIPO) is an international organisation dedicated to promoting the use and protection of works of the human spirit and can be found at www.wipo.org.

>>IP Australia is the federal government agency that grants rights in patents, trade marks and designs and can be found at: www.ipaustralia.gov.au

>>The European Patent Office is another good source of information: www.european-patent-office.org.

>>Trademark: Legal Care for your Business & Product Name, (NOLO Press, 1999) is also a good source of information.

Terms & Techniques

A Series>>Refers to the international ISO or DIN range of paper sizes. The sizes reduce proportionally from the largest, AO, by folding in half.

Antique A>>High quality bulky paper with a rough finish.

Art Paper>>Coated paper with a gloss finish.

B Series>>Refers to the international ISO range of paper sizes for items that require a larger format than standard A sizes.

Blind Embossing/ Debossing>>Embossing or debossing without the use of foil or ink to create a raised design that is made visible by the shadows cast by the area in relief.

Banker>>An envelope with a half diamond-shaped flap on the long edge.

Base Paper>>Paper before it has been coated.

Basis Weight>>The weight of paper in grammes per square metre.

Bible Paper>>A very thin paper.

Bleed>>The layout image area that extends beyond the trim edge.

Board>>General term used when referring to any paper over 220gsm.

C Series>>ISO envelope sizes that fit A series paper sizes.

China Clay>>White refined clay used for coating paper.

Coated Paper>>Paper that has been coated in china clay or similar material to give a smooth surface with a gloss, matt or satin finish. Also known as art paper.

Continuation Sheet>>A secondary sheet of the letterhead that usually features elements of the design on the letterhead but without address details.

Corporate Identity>>The process whereby unity is given to the visual aspects of a company's personality through design to identify its internal and external communications, products, or services. At its most basic level it involves the creation of a logo or trademark and its controlled application to the required material.

Custom Making>>Also known as bespoke it can refer to paper or a typeface made to a client's own specification.

Debossing>>Reverse effect of embossing to produce an impression that is sunk into the surface. See embossing.

Deckle Edge>>Paper with an untrimmed feathery uneven edge.

Die>>A metal stamp crafted from artwork and used by the printer to create embossings, cut shapes, to apply foil or alter the flat surface of the paper.

Die-Cutting>>Area or shape cut from a sheet of paper using a die.

Die-Stamping>>Similar process to embossing but with a die. The recess created is coated with ink.

DIN>>Abbreviation of the Deutsche Industrie Norm, a set of industry standards established in Germany in the 1920s and now used across Europe. Subsequently adopted by the International Standards Organisation (ISO).

Double Hit>>Printing the sheet twice to increase the density of ink. Can also refer to embossing where the paper is stamped twice to increase depth.

Embossing>>Creating a raised design on the surface of the paper created by pressing the sheet between two interlocking blocks, one of which has a raised design on it, the other a matching depression.

Enamel Paper>>High gloss coated on one side.

Fibres>>The basic structural material in all sheets of paper.

Fine Papers>>High-quality papers.

Finishing>>The process that sees the final item applied to the paper e.g. die-cutting.

Foil-Blocking>>The application of a thin layer of metal or foil to the surface of the paper using a metal block, heat and pressure to produce a smooth shiny surface.

Font>>Traditional term for complete sets of alphabets relating to one size of typeface including upper- and lower-case roman, italics, bolds, figures and punctuation marks.

Foot>>The bottom of the page.

Four-Colour Printing>> Process of producing printed colour using four separate plates to print yellow, magenta, cyan and black.

Gloss>>The shiny appearance of a sheet of paper.

GSM>>Grams per square metre, used to define stock weights.

Head>>Top of the page.

House Style>>A set of guidelines ensuring consistency throughout all of a company's communications, usually set out in a Style Manual.

Ink-Jet Printer>>Computer linked printing device in which images are created by high-speed jets of ink.

ISO>>See DIN

Ivory Board>>Smooth board often used for business cards.

Kerning>>The space between typeface characters.

Lamination>>A film applied to printed sheets either for protection or to achieve a particular finish.

Laser Cutting>>Very fine cutting by laser used when traditional die-cutting cannot achieve a particular finish.

Laser Printer>>Common computer-linked desk-top printer in which beams of light activate a photo-conductive powder, creating

an electrostatic image which is transferred to the paper through heat.

Leading>>The amount of vertical space between the baselines of a typeface.

Letterpress>>Traditional form of relief printing in which ink is applied to the paper through pressure. Raised blocks of type and image are pressed onto the sheet leaving an impression.

Litho>>Abbreviation, see offset litho.

Logotype>>Letters or words in a distinctive and unified form. Often used as, or as part of, a company logo.

Matt>>Paper with non-glossy surface.

Offset/Litho Printing>>The most common printing process based on the principle that oil and water do not mix.

Opacity>>The extent to which print on the reverse side of a piece of paper shows through.

Pocket>>Envelope with the flap on the short edge.

Sans Serif>>A typeface that does not have an end stroke or foot.

Serif>>The end stroke or foot of a type character.

Spot Varnish>>Varnish applied to a specific area of a printed sheet.

Stock>>The design industry's term for paper.

Thermography>>A raised, glossy surface created by sprinkling resin onto wet ink.

Tooth>>Rough texture of the paper surface.

Trademark>>Company identification device in the form of a symbol or logotype.

Type Family>>Two or more typefaces with a common design.

Typeface>>One variation of a type family with a specific weight, width or slope.

Typography>>The arrangement and specification of a type for printing.

Uncoated Paper>>A paper with no clay coating (see matt).

Wallet>>An envelope with a square flap on the long edge.

Weight>>See GSM

Designer Directory

Airside – UK
info@airside.co.uk>>www.airside.co.uk

Anker XS – Holland
menno@ankerxs.nl>>www.ankerxs.nl

Artomatic – UK
daniel@artomatic.co.uk>>www.artomatic.co.uk

Atelier Works – UK
john@atelierworks.co.uk>>www.atelierworks.co.uk

ATTIK – UK/USA
Info.lo@attik.com>>www.attik.com

Ausra Lisauskiene – Lithuania
ausralisauskiene@org.ktu.lt

Azone and Associates – Japan
iInfo@azone.co.jp>>www.azone.co.jp

BCPT Associati – Italy
mtr@bcpt.com>>www.bcpt.com

Big Active – UK
bp@bigactive.com>>www.bigactive.com

Blast – UK
studio@blast.co.uk>>www.blast.co.uk

Bobbett Design – UK
krichards@bobbett.com>>www.bobbett.com

Browns – UK
Info@brownsdesign.com>>www.brownsdesign.com

Cartlidge Levene – UK
ian.cartlidge@cldesign.co.uk>>no website

CHK Design – UK
christian@chkdesign.demon.co.uk>>www.acmefonts.net

CoDe Communication and Design – USA
jenny8@code-network.com>>www.code-network.com

Crescent Lodge – UK
info@crescentlodge.co.uk>>www.crescentlodge.co.uk

DA – UK
info@dacreative.com>>www.dacreative.com

Eggers and Diaper – Germany
be.md@t-online.de

Elliott Borra Perlmutter – UK
info@ebpcreative.com>>www.ebpcreative.com

Fly Productions – UK
people@flyprod.u-net.com

Frost Design – UK
info@frostdesign.co.uk>>www.frostdesign.co.uk

Glazer – UK
design@glazer.co.uk>>www.glazer.co.uk

Graphic Thought Facility – UK
info@graphicthoughtfacility.com>>
www.graphicthoughtfacility.com

HDR visual communications – UK
mail@hdr-online.com>>www.hdr-online.com

HGV – UK
design@hgv.co.uk>>www.hgv.co.uk

idle – USA
jojojaja@earthlink.net

Insect – UK
info@insect.co.uk>>www.insect.co.uk

Joao Machado Design – Portugal
j.antonio@joaomachado.com>>www.joaomachado.com

Jekyll & Hyde – Italy
info@jeh.it>>www.jeh.it

Johnson Banks – UK
info@johnsonbanks.co.uk>>www.johnsonbanks.co.uk

KesselsKramer – Holland
church@kesselskramer.com>>www.kesselskramer.com

KOREK Studio – Poland
korek@korekstudio.com.pl>>www.korekstudio.com.pl

Lamosca – Spain
info@lamosca.com>>www.lamosca.com

Martin Woodtli – Switzerland
martin@woodt.li>>www.woodt.li

Mattmo concept | design – Holland
contact@mattmo.nl>>www.mattmo.nl

MetaDesign – Germany
mail@metadesign.de>>www.metadesign.com

Michael Nash Associates – UK
info@michaelnash.co.uk

Milch Design – Germany
info@milch-design.de>>www.milch-design.de

Moot Design – UK
moot@btinternet.com>>www.moot.co.uk

Mytton Williams – UK
design@myttonwilliams.co.uk>>www.myttonwilliams.co.uk

NB:Studio – UK
mail@nbstudio.co.uk>>www.nbstudio.co.uk

NE6 – UK
info@ne6design.co.uk

Nevis Design – UK
info@nevisdesign.co.uk

Nofrontiere – Austria
ask@nofrontiere.com>>www.nofrontiere.com

Odermatt and Tissi – Switzerland
phone only + 41 1211 94 77

Ongarato – Australia
studio@ongarato.com.au>>www.fodesign.com.au

Pentagram – UK/USA
email@pentagram.co.uk>>www.pentagram.co.uk

Peter and Paul – UK
peter@peterandpaul.co.uk>>www.peterandpaul.co.uk

Peter Heykamp – Holland
peterheykamp@yahoo.com>>no website

Pierre Emmanuel Meunier – France
pierre.emm@caramail.com

PRE Consultants Ltd – UK
paul@pre.co.uk>>www.pre.co.uk

Prof Design – Russia
info@profdesign.ru>>www.profdesign.ru

R2 Design – Portugal
liza@rdois.com>>www.rdois.com

Real451 – UK
diversity@real451.com>>www.real451.com

Reddie & Grose Attorneys – UK
helen.wakerley@reddie.co.uk>>www.reddie.co.uk

SEA Design – UK
info@seadesign.co.uk>>www.seadesign.co.uk

SEGURA INC – USA
carlos@segura-inc.com>>www.segura-inc.com

Sensus Design Factory – Croatia
nedjeljko.spoljar@zg.tel.hr

Simon and Lars – UK
simonandlars@yahoo.co.uk

Studio PK – Poland
studiopk@asp.lodz.pl

SWIP STOLK – Holland
studio@swip-stolk.nl>>www.swip-stolk.nl

TheFarm – UK
studio@thefarm.co.uk>>www.the-farm.co.uk

Thirstype – USA
chester@thirstype.com>>www.thirstype.com

Thompson Design – UK
ian@thompsondesign.co.uk >> www.thompsondesign.co.uk

Tonic – UK
design@tonic.co.uk>>www.tonic.co.uk

Trafik – France
damien.trafik@wanadoo.fr>>www.lavitrinedetrafik.com

TUGBOAT – Japan
mail@tugboat.jp

Twelve:ten design – UK
rob@twelveten.com>>www.twelveten.com

Why Not Associates – UK
info@whynotassociates.com>>www.whynotassociates.com

Wild and Frey – Switzerland
office@wildfrey.ch

Yorgo Tloupas
yorgo@intersectionmagazine.com

Further Reading

Books consulted during the writing of this book or relevant to the study of identity.

>>Pilditch, James – Communication by Design – McGraw-Hill (1970)

>>Klein, Naomi – No Logo – Flamingo (2000)

>>Williams, Nancy – Paperwork: The potential of paper in graphic design – Phaidon (1993)

>>Lloyd-Morgan, Conway – Logos: Logo, identity, brand, and culture – RotoVision (1999)

>>Barrett, Amanda – Corporate Image: For professional communicators – Batsford (1988)

>>Ollins, Wally – Corporate Identity: Making business strategy visible through design – Thames and Hudson (1989)

>>Murray, Ray – Designers and Art Directors: Manual of Technique – Business Books (1977)

>>Lupton, Ellen and Miller, J. Abbot – Design Writing Research: Writing on graphic design – Phaidon (1996)

>>Oldach, Mark – Creativity for Graphic Designers – North Light Books (1995)

>>Bernstein, David – Company Image and Reality – Holt Rinehart Winston (1984)

>>Ind, Nicholas – The Corporate Image – Kogan Page (1990)

>>Selame, Elinor and Selame, Joe – The Company Image – Wiley (1988)

>>Poyner, Rick – The Graphic Edge – Booth-Cliborn Editions (1993)

>>Craig, James – Production for the Graphic Designer – Pitman Publishing (1974)

>>Cotton, Bob – The New Guide to Graphic Design – Phaidon (1990)

>>Lupton, Ellen – Mixing Messages: Contemporary Graphic Design in America – Thames and Hudson (1996)

Acknowledgements

Many great designers have contributed to this book so my initial thanks and appreciation goes to them for submitting work for inclusion and taking the time to discuss it with me.

I also wish to thank photographer Xavier Young for the outstanding photography throughout the book, Mark Diaper for his creative contributions and advice, Daniel Mason at Artomatic for his last minute help, Laura Owen at Rotovision for her patience, James Emmerson for his excellent design of the book and Chris Foges for the opportunity to write it.

Further thanks to Helen at Reddie and Grose and Chris Barrett at KesselsKramer.

A special thanks goes to Simon Henwood for his continuous support and encouragement.

This book is for Meg.

Charlotte Rivers